FILM VAULT

VOLUME 8

The Order of the Phoenix and Dark Forces

By Jody Revenson

WIZARDING WORLD

INSIGHT ◉ EDITIONS

SAN RAFAEL • LOS ANGELES • LONDON

INTRODUCTION

When Harry Potter learns he's a wizard in *Harry Potter and the Sorcerer's Stone*, he also finally learns the significance of the lightning bolt–shaped scar on his forehead. Sitting in the Leaky Cauldron with Rubeus Hagrid, Keeper of Keys and Grounds at Hogwarts School of Witchcraft and Wizardry, Harry hears the story of "The Boy Who Lived." "Not all wizards are good," Hagrid tells Harry. "Some of them go bad. A few years ago, there was one who went as bad as you can go. And his name was . . . Voldemort."

In his desire for ultimate power over the wizarding world, the self-styled Dark Lord Voldemort gathered followers from among his former Slytherin schoolmates and other malcontents to become his Dark forces. He also eliminated anyone who stood against him. Over the course of a decade, Voldemort's powers and fighting army increased. Then realizing that, according to prophecy, Harry was the only wizard who could defeat him based on the circumstances of his birth, Voldemort cast the Killing Curse at Harry when he was only an infant. But Harry survived, branded with a distinctive scar on his forehead. That same night, Harry's parents, James and Lily Potter, were killed and Voldemort disappeared.

In the years before their deaths, James and Lily had been part of an underground organization begun by Albus Dumbledore called the Order of the Phoenix. James and Lily's son, Harry, went on to study at Hogwarts during Dumbledore's tenure as Headmaster, as did children of other Order members and children of Voldemort's followers, the Death Eaters. Though Voldemort was thought gone, which the wizarding world had hoped was for good, he regained his physical body and his powers during Harry's fourth year at school in *Harry Potter and the Goblet of Fire*.

Producer David Heyman's first choice to play the Dark Lord was actor Ralph Fiennes. "Ever since the beginning, I thought of Ralph Fiennes as Voldemort. You know, Voldemort has to be attractive. Ralph Fiennes is attractive. He has to seduce you. You have to understand why people are attracted to him and yet he has to be the embodiment of evil. Ralph brings the complexity, the coolness, and the charisma that is Voldemort."

Goblet of Fire features the Triwizard Tournament, a competition hosted at Hogwarts between three wizarding schools, which hasn't been held for hundreds of years. "For the

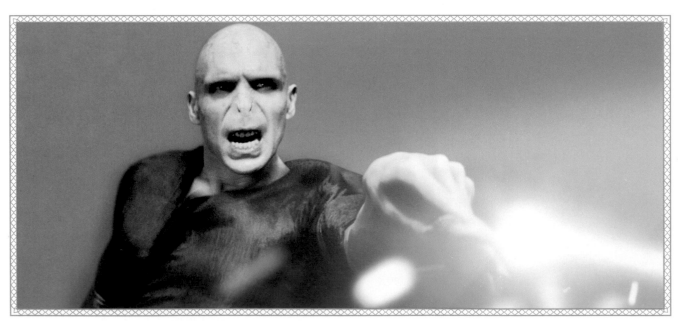

PAGE 2: Concept art of a Death Eater by Rob Bliss for *Harry Potter and the Order of the Phoenix*; ABOVE: Voldemort duels with Harry Potter in *Harry Potter and the Goblet of Fire*; OPPOSITE: Concept art of Professor Moody by Adam Brockbank for *Harry Potter and the Goblet of Fire*.

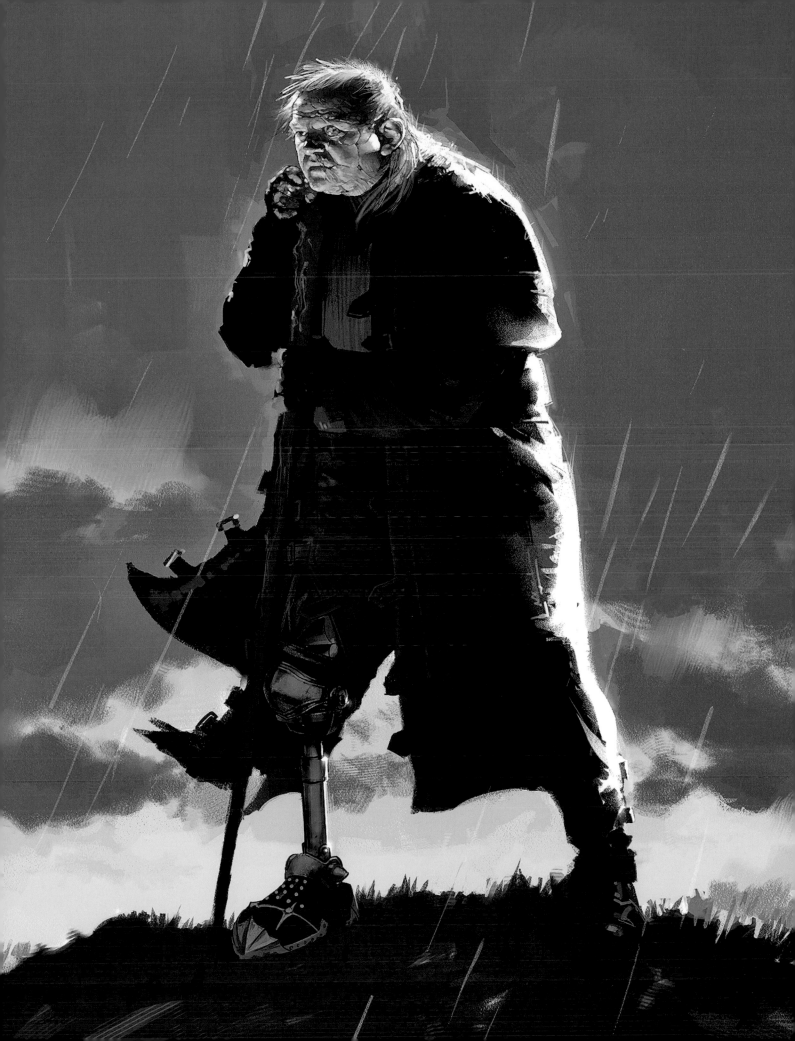

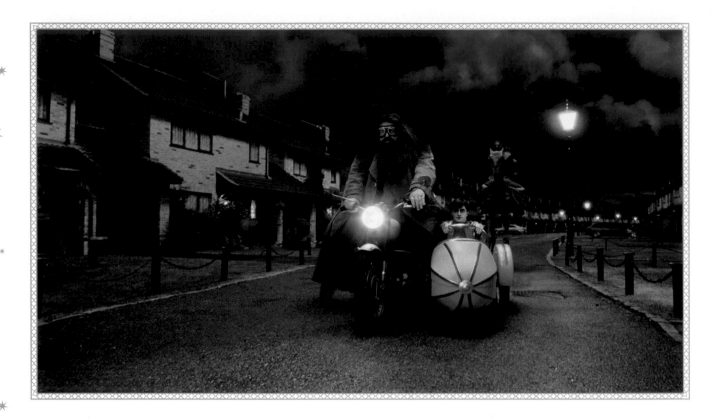

first time, we're exposed to the wizarding schools from other countries," says Heyman. "And one of the reasons Dumbledore is doing this is to encourage international friendships. Because what lies ahead are Voldemort and the Death Eaters. Fourteen years ago were not good times, and we're on the precipice of times like that again. The way to counter that is international unity, community, and getting along with people who are different [from] you."

Even though the contest achieves its goal of forming strong unions among the young wizard community, Harry receives a direct warning from the head of the original Order. "Dark and difficult times lie ahead," says Dumbledore as the events of *Goblet of Fire* wind down. "Soon we must all face the choice between what is right and what is easy. But remember this—you have friends here. You're not alone."

In *Harry Potter and the Order of the Phoenix*, Harry discovers that the Order has been reestablished with new members to battle Voldemort's second campaign for power. He meets several of them when they come to rescue him from the Dursleys. His Muggle aunt and uncle had locked him in his room after Harry was forced to battle two Dementors near their house on Privet Drive to save himself and his cousin, Dudley. When Harry returns to school, after a trial at the Ministry of Magic for the use of underage magic, he's ostracized by classmates who don't or won't believe that Voldemort has returned, especially as the Ministry refuses to accept what Harry has seen. "Harry's journey in this particular story is of being a bit of an outsider," says Heyman. "Feeling as if people do not trust him, do not believe him, feeling like he doesn't belong." Ultimately—and fortunately—he finds that he does belong. "And not only does he belong," adds Heyman, "but he has people who are willing to follow him."

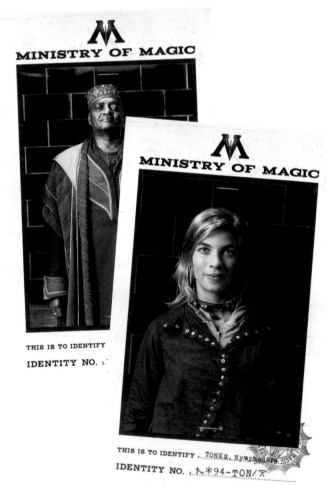

MINISTRY OF MAGIC

THIS IS TO IDENTIFY :

IDENTITY NO. :

MINISTRY OF MAGIC

THIS IS TO IDENTIFY :. TONKS, Nymphadora

IDENTITY NO. :. 大*94-TON/大

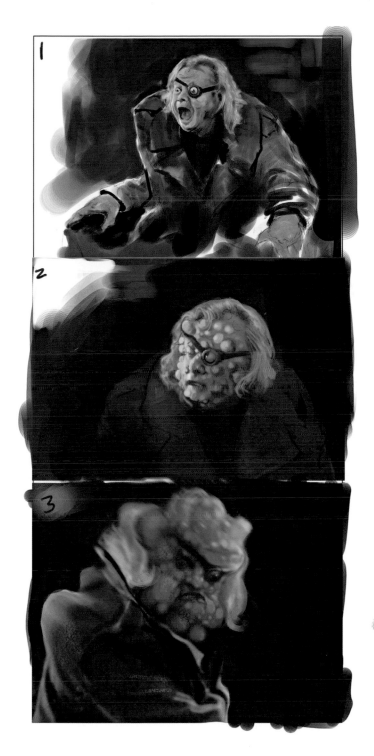

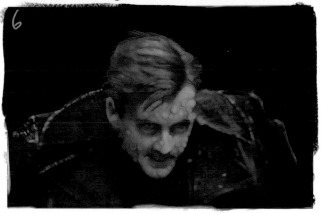

OPPOSITE TOP: Rubeus Hagrid (Robbie Coltrane) and Harry Potter (Daniel Radcliffe) make their escape from Privet Drive in a film still from *Harry Potter and the Deathly Hallows – Part 1*; OPPOSITE BOTTOM: Identity cards accompanying Kingsley Shacklebolt's and Nymphadora Tonks's Muggle-Born Registration Commission forms, from a filing cabinet in Dolores Umbridge's office at the Ministry of Magic in *Harry Potter and the Deathly Hallows – Part 1*; THIS PAGE: Concept art by Paul Caitling for *Harry Potter and the Goblet of Fire* envisions how the Polyjuice Potion would fade to reveal Barty Crouch Jr.

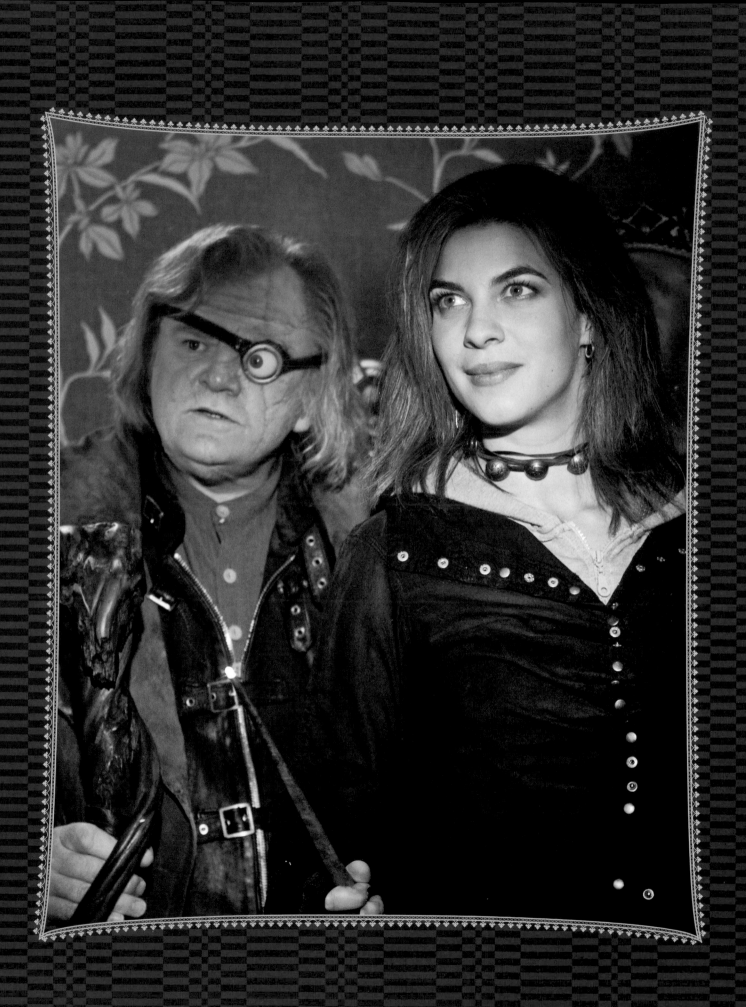

CHAPTER 1
THE ORDER OF
THE PHOENIX

THE ORIGINAL ORDER OF THE PHOENIX

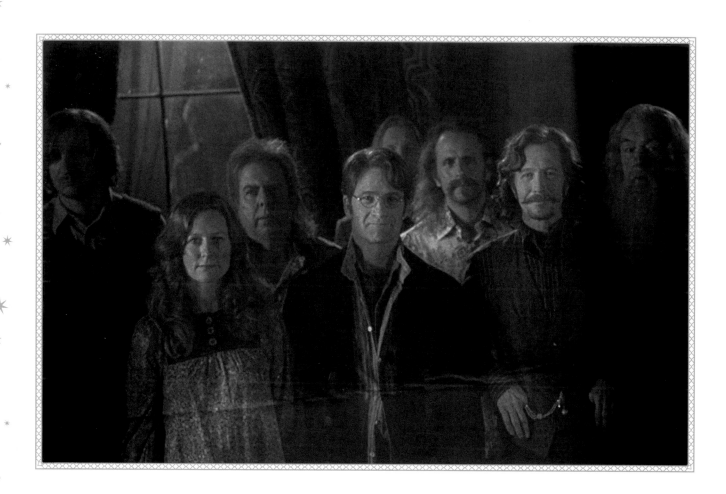

The Order of the Phoenix was formed by Professor, and eventual Hogwarts Headmaster, Albus Dumbledore in the early 1970s to fight against the threat of a growing movement of intolerance for non-magical people and wizards with non-magical ancestry. The Order became active at the outset of the First Wizarding War, when Lord Voldemort and his Dark followers tortured and killed those who opposed him.

Voldemort—himself a half-blood wizard born Tom Marvolo Riddle—believed in the superiority of wizards over non-magical Muggles as well as the superiority of pure-blood wizards over wizards who had some Muggle blood in their family line. Orphaned at an early age, he was brought to Hogwarts by Dumbledore, who recognized his magical ability, as seen in flashbacks in *Harry Potter and the Half-Blood Prince*. Riddle was highly skilled but also manipulative and discriminatory. As Riddle grew older, he

developed an interest in creating Horcruxes, one of the darkest of magical acts, as these objects preserve fragments of a wizard's soul in order to achieve a form of immortality. Leaving Hogwarts, he commenced a pursuit of power and domination and, within a number of years, became the most feared Dark wizard in a century. Voldemort's most passionate followers were called Death Eaters, and as their numbers grew, they began to attack "blood traitors"—pure-bloods who did not support Voldemort and his ideas.

At a breaking point, Albus Dumbledore assembled a group to combat these Dark forces, which included longtime friends Emmeline Vance and Elphias Doge as well as Hogwarts alumni James Potter and Lily Evans, Sirius Black, Peter Pettigrew, and Remus Lupin. Other members were Arthur and Molly Weasley; Hogwarts' gamekeeper Rubeus Hagrid; and Aurors Frank and Alice Longbottom and Alastor Moody.

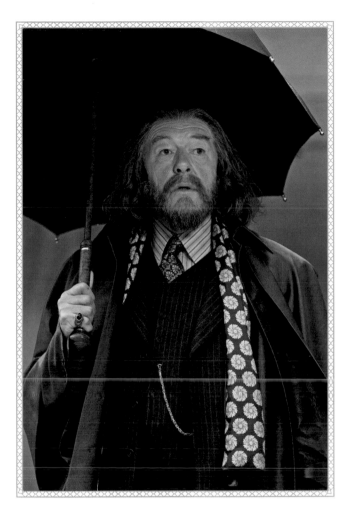

More than ten years of war ensued. Then in July 1980, Voldemort learned of a prophecy that foretold of a boy wizard born at the end of that month who would have the power to defeat him. Of the two possibilities born on July 31—Neville Longbottom, the son of Frank and Alice, and Harry Potter, the son of Lily and James—the Dark Lord chose to search for the latter. On October 31, 1981, after killing James and Lily, Voldemort cast the Killing Curse, *Avada Kedavra*, on the infant Harry, which shockingly rebounded onto the Dark wizard. Voldemort vanished, but because fragments of his soul had been placed into Horcruxes, he was still bound to the earth, though neither as a ghost nor a spirit.

Voldemort's followers were rounded up, and many Death Eaters, including Bellatrix Lestrange and Bartemius Crouch Jr., were sent to Azkaban Prison after their trials. Others supporters, such as Lucius Malfoy, declared that they had been under the Imperius Curse and so were not responsible for their actions. Those who remained loyal to Voldemort's cause attempted to retreat into obscurity, though their allegiance to the Dark Lord remained a poorly kept secret. With the wizarding world returned to stability and peace, the Order of the Phoenix disbanded.

PAGE 8: Two members of the Order of the Phoenix: Mad-Eye Moody (Brendan Gleeson) and Nymphadora Tonks (Natalia Tena); OPPOSITE: A photo given to Harry of the original Order of the Phoenix during the First Wizarding War—(left to right) Remus Lupin (David Thewlis), Lily Potter (Geraldine Somerville), Peter Pettigrew (Timothy Spall), James Potter (Adrian Rawlins), Edgar Bones (Cliff Lanning), and Sirius Black (Gary Oldham). Albus Dumbledore (Michael Gambon) peers in from the far right; THIS PAGE: Albus Dumbledore, fashion icon, visits Tom Riddle (Hero Fiennes-Tiffin) at the Wool Orphanage to invite him to Hogwarts.

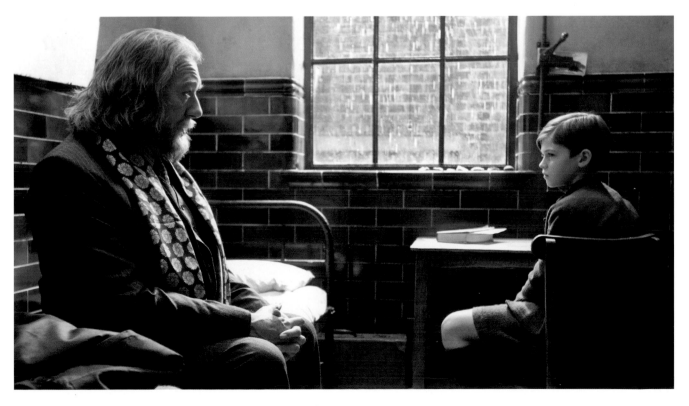

JAMES & LILY POTTER

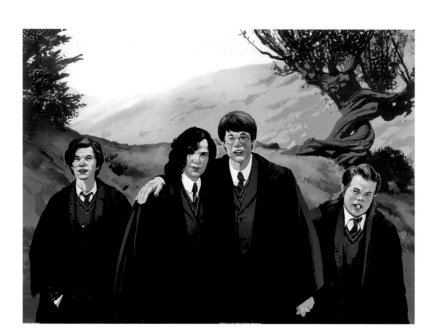

JAMES POTTER

FIRST APPEARANCE:
Harry Potter and the Sorcerer's Stone

ADDITIONAL APPEARANCES:
Harry Potter and the Chamber of Secrets
Harry Potter and the Prisoner of Azkaban
Harry Potter and the Goblet of Fire
Harry Potter and the Order of the Phoenix
Harry Potter and the Deathly Hallows – Part 1
Harry Potter and the Deathly Hallows – Part 2

HOUSE:
Gryffindor

MEMBER OF:
Order of the Phoenix

ADDITIONAL SKILL SET:
Animagus ("Prongs," a stag)

PATRONUS:
Stag

Throughout the course of the films, Harry Potter is given glimpses of his parents, James and Lily, through the Mirror of Erised in *Harry Potter and the Sorcerer's Stone* and in photos given to him in *Harry Potter and the Chamber of Secrets, Harry Potter and the Prisoner of Azkaban,* and *Harry Potter and the Order of the Phoenix.* In their adult years, James and Lily are always fashionably, but modestly and casually, dressed in muted colors and classic tailoring.

While at Hogwarts, James belonged to a group affectionately known as the Marauders. These Gryffindor students, including Sirius Black and Peter Pettigrew, learned to become Animagi to help their fourth member and friend—Remus Lupin, a werewolf. These young wizards banded together, and for *Harry Potter and the Prisoner of Azkaban* director Alfonso Cuarón, "band" was the operative word. Initially, the Marauders were to be seen in a flashback in the movie, and so Cuarón gave some thought as to who they were and what they looked like. "I was adamant about grounding everything, including the characters, in reality. When I read the books, for me it was very clear that the universe that J. K. Rowling wrote is not a precious one; I think it's very mischievous, even wicked." With that playful idea in mind, Cuarón

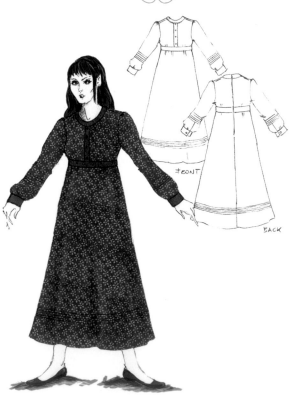

INSET: Adrian Rawlins as James Potter; RIGHT: Costume sketch for Lily Potter's dress worn in the Order of the Phoenix photo, sketch by Mauricio Carneiro; TOP AND OPPOSITE: The Marauders as envisioned by Adam Brockbank—(left to right) Remus Lupin, Sirius Black, James Potter, and Peter Pettigrew—and confronting Severus Snape (against the tree), by artist Andrew Williamson, both for *Harry Potter and the Order of the Phoenix.*

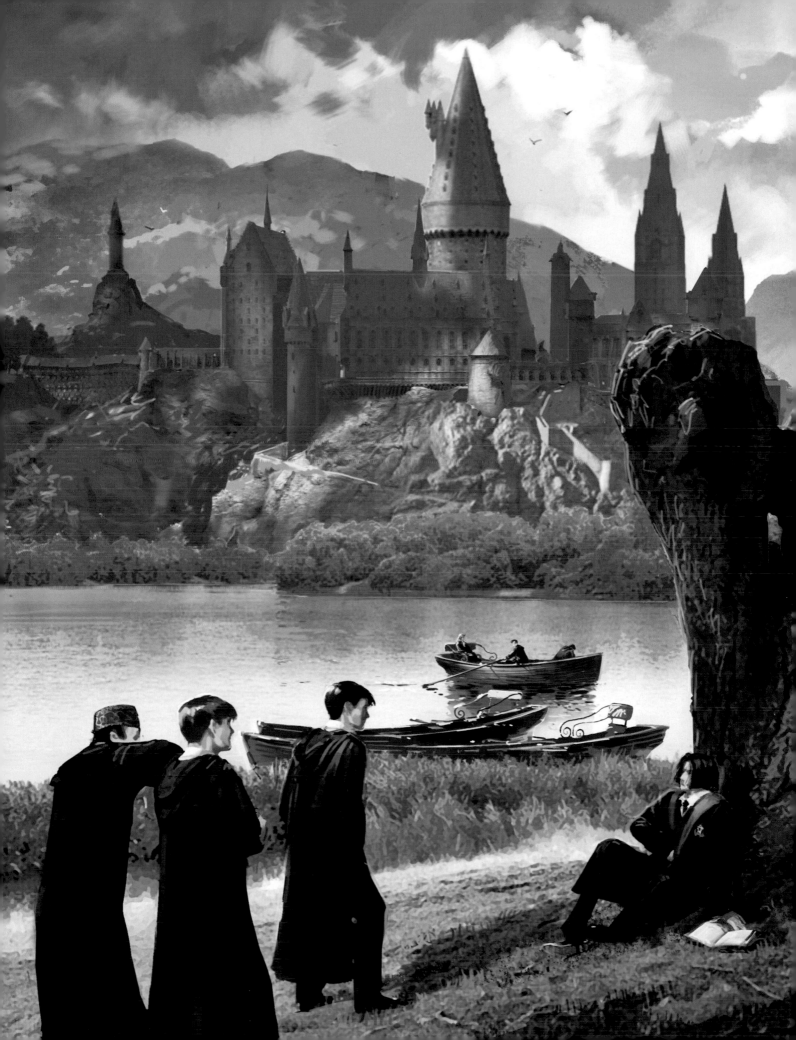

looked to the Muggle world for inspiration on a group of four young men who had formed an alliance. "We had seen flashbacks of [Harry's] parents, and I thought that James was actually a very cool dude. And this is when I started thinking that the flashbacks should look as if they were the Beatles, circa the late sixties/early seventies." Cuarón felt that James reminded him of John Lennon. Gary Oldman remembers the Fab Four equivalent a little differently, however. "James was like Paul—good looking and sure of himself—and Sirius was like John as he was a little bit reckless, a bit of an anarchic troublemaker." The Marauders weren't seen on-screen until *Harry Potter and the Order of the Phoenix*, but Cuarón's influence remained. James Potter wears round wireframe glasses and has a mop-top haircut; each of the Marauders has fledgling sideburns. Their Hogwarts robes of that earlier time have thinner collars and their trousers' waistlines are set lower on the hips.

Harry Potter and the Order of the Phoenix's titular group is seen in a photograph featuring a more mature group of Marauders surrounded by other members of the Order. Being a few years later, their clothes are firmly rooted in the seventies: midi-length peasant dresses embellished with velvet, Nehru collars, and fisherman's caps, albeit with a wizardy approach.

LILY POTTER

FIRST APPEARANCE:
Harry Potter and the Sorcerer's Stone

ADDITIONAL APPEARANCES:
Harry Potter and the Chamber of Secrets
Harry Potter and the Prisoner of Azkaban
Harry Potter and the Goblet of Fire
Harry Potter and the Order of the Phoenix
Harry Potter and the Half-Blood Prince
Harry Potter and the Deathly Hallows – Part 1
Harry Potter and the Deathly Hallows – Part 2

HOUSE:
Gryffindor

MEMBER OF:
Order of the Phoenix

PATRONUS:
Doe

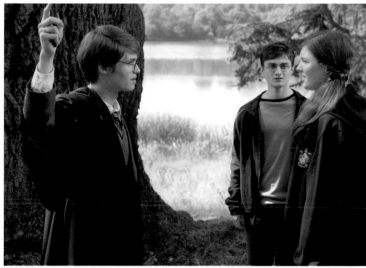

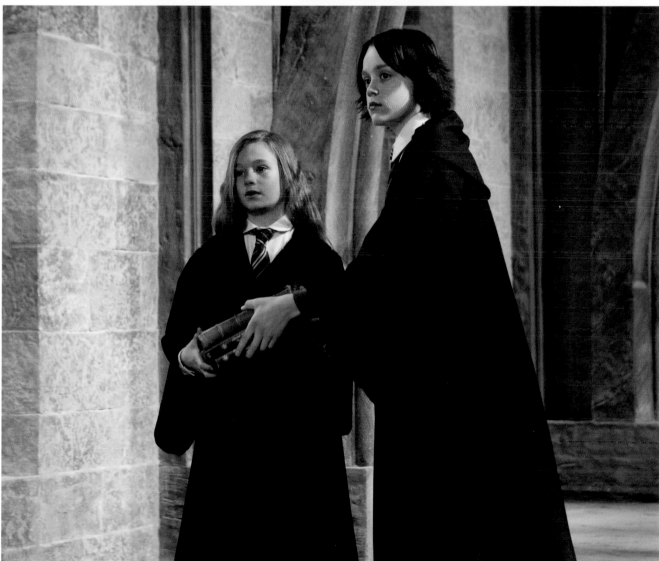

OPPOSITE TOP: A Pensieve memory of Severus Snape's in *Harry Potter and the Order of the Phoenix* shows the young Marauders in earlier versions of the Hogwarts robe—(left to right) Sirius/Padfoot (James Walters), James/Prongs (Robert Jarvis), Remus/Moony (James Utechin, middle back), and Peter/Wormtail (Charles Hughes); TOP LEFT AND ABOVE: Another Pensieve memory of Snape's in *Deathly Hallows – Part 2* shows young Lily Potter (Ellie Darcey-Alden) with young Snape (Benedict Clarke) at Hogwarts; TOP RIGHT: Harry Potter watches his parents—James (Robert Jarvis, left) and Lily (Susie Shinner)—as older Hogwarts students in a Pensieve memory in *Order of the Phoenix*.

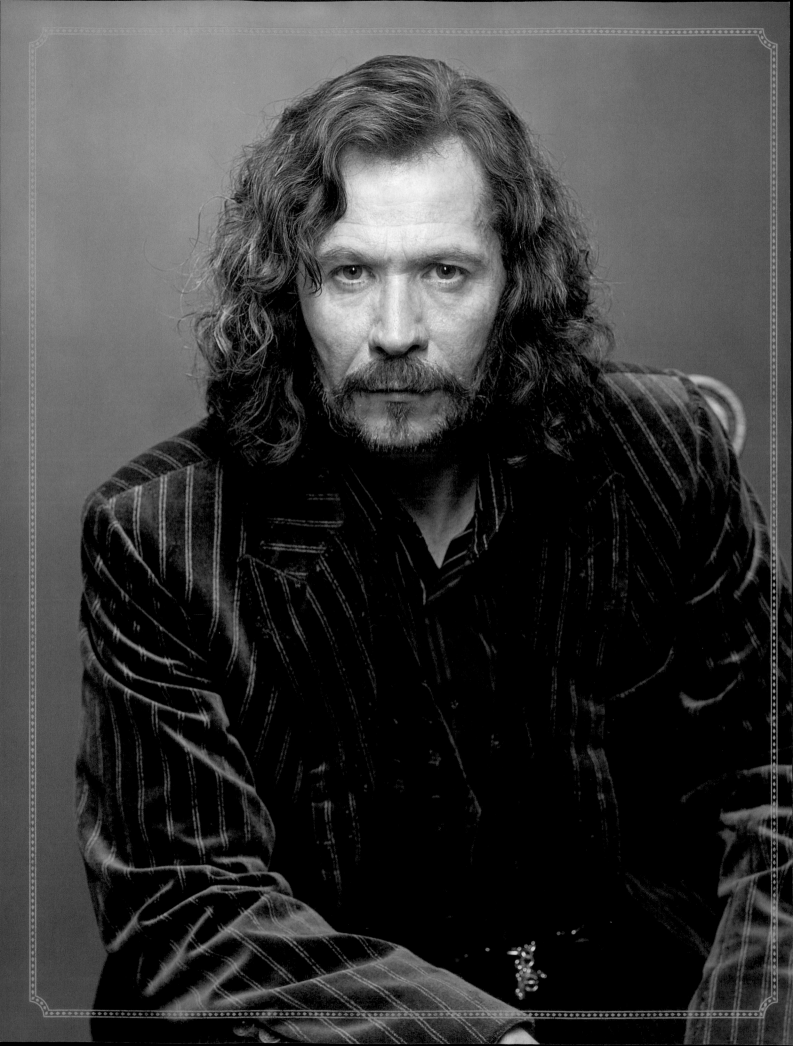

SIRIUS BLACK

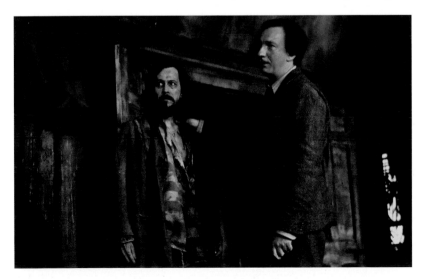

"The first time you see me," says Gary Oldman of his appearance in *Harry Potter and the Prisoner of Azkaban*, "I've just escaped after twelve years in prison. So I'm pretty much a disheveled wreck, an undernourished guy in need of some dental work, a shave, and some decent clothes." Jany Temime spent some time thinking about how a prisoner in Azkaban would be dressed, and drafted several different possibilities, "But then I thought, a prisoner is a prisoner. A prisoner wears something dirty and striped. And that's it." Wide horizontal stripes were chosen for the pajama-style prisoner clothes, and Sirius wears a beaten-up coat that he picked up somewhere after his escape. There were also numerous tests for Sirius Black's hair. "We tried it short and long," recalls Oldman. "Very short gray hair, or almost bald with tufts of hair, like it was falling out. Bearded and not bearded. The book says he has long, greasy hair and that's what we ended up with." A scraggly gray beard and moustache were added. The makeup crew provided a set of rotten teeth, and covered his body in tattoos that featured runic and alchemical symbols, suggested by director Alfonso Cuarón. For his brief appearance in *Harry Potter and the Goblet of Fire*, seen in a fire's flames, Oldman was filmed in a cleaned-up version of the same long wig and facial hair.

Based on the look of Sirius Black and the other Marauders during their years at Hogwarts, in Cuarón's tip to the Beatles, the Sirius seen in *Harry Potter and the Order of the Phoenix* almost recaptures the glory of his youth. Now he sports a trimmed moustache and set of light mutton chops, reminiscent of John Lennon in late 1968. Jany Temime assumed that Black had kept his clothes at his Grimmauld Place home while he was in prison, and was wearing them again,

FIRST APPEARANCE:
Harry Potter and the Prisoner of Azkaban

ADDITIONAL APPEARANCES:
Harry Potter and the Goblet of Fire
Harry Potter and the Order of the Phoenix
Harry Potter and the Deathly Hallows – Part 2

HOUSE:
Gryffindor

OCCUPATION:
Fugitive

MEMBER OF:
Order of the Phoenix

ADDITIONAL SKILL SET:
Animagus ("Padfoot," a dog)

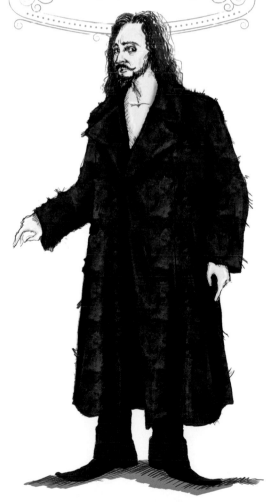

INSET AND OPPOSITE: Gary Oldman as Sirius Black; ABOVE: A recently escaped Sirius meets up with fellow Marauder Remus Lupin in *Harry Potter and the Prisoner of Azkaban*; RIGHT: Jany Temime's design of Sirius's coat for *Harry Potter and the Order of the Phoenix*, sketch by Mauricio Carneiro.

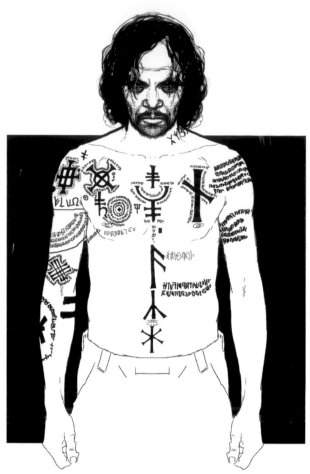

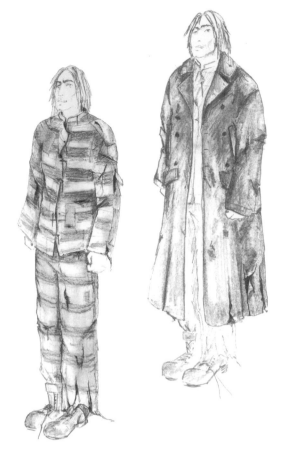

although through the course of time they had become a bit faded and moth-eaten. "He was a rock star then," says Temime. "He was popular and glamorous. I supposed that Sirius still had that wonderful wardrobe in his closet and would want to wear it again. And he wore it brilliantly, but, of course, after being dressed in rags, whatever he wore would look fantastic." Sirius is dressed in crushed velvets, embroidered vests strung with gold watch chains, and a pair of low-heeled boots that Oldman deemed "fabulous." Typical of the late sixties time period, patterns were mixed and matched, and so Sirius wears a series of striped shirts and blazers that contrast with his vests and pants. The velvet waistcoat he wears in the Ministry of Magic battle was dyed and then a printing technique called "devore" was used to burn a pattern of roses into the fabric. These flowers were then painted to look like embroidery that had worn away over the years. Oldman admits, though, that "When you're up there in the Veil Room, wafting your wand, in double velvet, it gets hot. I was much cooler in the Azkaban prison wear."

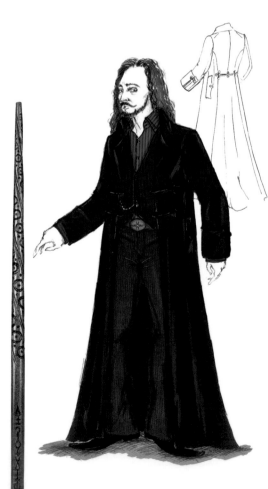

SIRIUS'S WAND

Sirius Black's wand is simply shaped but highly decorated, and a combination of round and square. The shaft has a gentle, slow twist to it, decorated with a spiral line embellished with circular insets. These lead to a flattened handle adorned in runic symbols that complement the tattoos on Black's body. Actor Gary Oldman was instructed by wand battle choreographer Paul Harris to give his wand moves more of an angular, "street" feeling, which he thought befitted someone who had spent time in Azkaban. "It is similar in a way to fencing," says Oldman, "because there's blocks and deflections, you know. Defensive and attacking moves. Paul really created a language." In fact, five specific attack moves were devised, with names including "crux" (across the body) and "latros" (from behind the back).

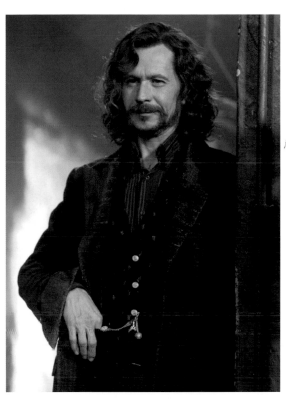

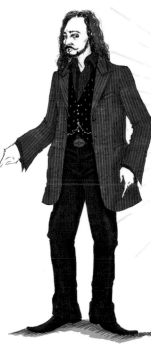

> *"It's been fourteen years, and still a day doesn't go by I don't miss your dad."*
>
> —SIRIUS BLACK
> *Harry Potter and the Order of the Phoenix*

OPPOSITE TOP LEFT: Artist Rob Bliss documented Sirius's Russian-style tattoos; OPPOSITE TOP RIGHT: Costume ideas for Sirius's Azkaban prison wear and the coat he picks up to hide it, in *Harry Potter and the Prisoner of Azkaban*, sketches by Laurent Guinci; OPPOSITE BOTTOM AND TOP RIGHT: Sketches by Mauricio Carneiro for *Harry Potter and the Order of the Phoenix* of Sirius's seventies-style suits; TOP LEFT: Echoes of a young Sirius Black are seen in his revitalized wardrobe for *Order of the Phoenix*; BELOW: Sirius with his godson, Harry Potter, at King's Cross station.

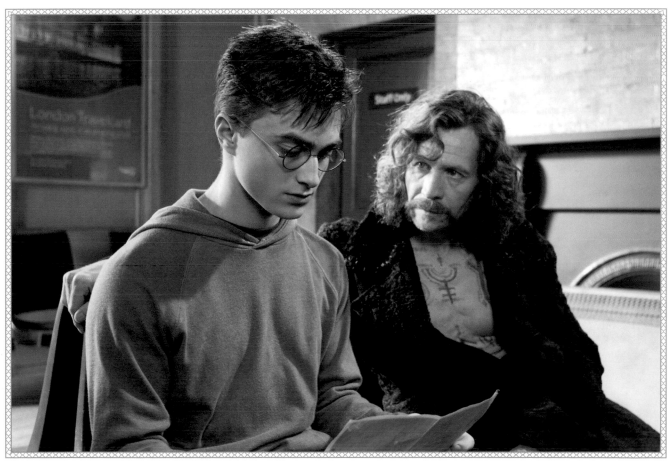

ABERFORTH DUMBLEDORE

In *Harry Potter and the Deathly Hallows – Part 2*, Harry, Ron, and Hermione must find a way inside Hogwarts castle in their pursuit of Voldemort's Horcruxes. So they Apparate to Hogsmeade, but their very presence sets off an alarm. While passing by the Hog's Head Inn, a voice directs them to a hiding place in its basement. The voice belongs to Aberforth Dumbledore, Albus's younger brother and an original member of the Order of the Phoenix.

Aberforth had been seen briefly in *Harry Potter and the Order of the Phoenix* when the students met at the Hog's Head to form Dumbledore's Army. Played by Jim McManus, in full Scottish regalia of plain tartan kilt and a sporran featuring a rodent-headed clasp, the character has minimal screen time and is not actually identified in the film. But in the last film in the series, Aberforth has an important part to play, protecting and helping Harry in his search and offering some heretofore unrevealed information about Albus Dumbledore. The filmmakers cast actor Ciarán Hinds in the expanded role. "He actually explains to Harry, Hermione, and Ron the history of his brother when they were young," Hinds explains. "How Albus Dumbledore is not all he said he was. It's that hole in the film that needed to be filled."

There definitely appears to be more of a business rather than a familial relationship between the brothers at this point. "There was a friction between them because of choices Albus made to the detriment of their little sister, Ariana," says Hinds. "And it would appear from the way Aberforth speaks of [Albus] that he just wasn't ever able to move on from that." Despite the separation, Aberforth is still committed to the cause of the Order of the Phoenix. "It's there," Hinds continues. "It's just not particularly done with good grace." Aberforth rebukes his brother for keeping secrets from Harry and placing him in a dangerous position. "In a way, Aberforth is like the last test," says Daniel Radcliffe. "He's giving me another chance to turn back and to pack it all in, actually, and it's the moment when Harry decides, 'If I don't carry on with this, what am I going to do?'" Despite Aberforth's obvious bitterness, Harry keeps faith with his longtime mentor.

The filmmakers didn't want the brothers to look exactly alike, but they did want to make sure there was enough of a resemblance so that the teens would realize quickly who had helped them. "In a way," says Nick Dudman, special makeup effects designer, "we transposed Michael Gambon's features onto Ciarán Hinds." Dudman worked with makeup designer Amanda Knight to create three prosthetics that would accentuate the similarities. A higher forehead was added, little bags were placed under his eyes, and Hinds was given a fuller and straighter nose bridge. "Mine's a bit crooked and thinner," says Hinds. "So, it's just these three features that transform the whole face."

An easily spotted difference is the two brothers' attire. "[Aberforth] dresses completely different from Albus," says Jany Temime, "because Aberforth owns a pub and Albus is a professor." Aberforth's robe is made from a roughhewn fabric with none of the ornamentation seen so frequently on Albus's clothes.

Hinds was delighted to be asked to play the part. "It was a mystery to me why I was thrown into the pot. I was just thrilled to be asked to be in the story at all, because I got in by the skin of my teeth!" he admits. "But to play Michael Gambon's younger brother was even more of a thrill."

FIRST APPEARANCE:
(unidentified) *Harry Potter and the Order of the Phoenix*

ADDITIONAL APPEARANCES:
Harry Potter and the Deathly Hallows – Part 2

HOUSE:
Unknown

OCCUPATION:
Owner and barkeep of the Hog's Head Inn, Hogsmeade

MEMBER OF:
Order of the Phoenix

PATRONUS:
Goat

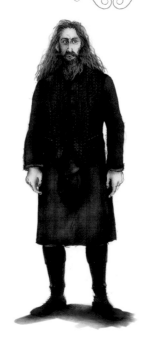

INSET AND OPPOSITE: Ciarán Hinds as Aberforth Dumbledore, Albus's younger brother, in *Harry Potter and the Deathly Hallows – Part 2*; ABOVE: Jany Temime's costume design of Aberforth as the barkeep of the Hog's Head in *Harry Potter and the Order of the Phoenix*, sketch by Mauricio Carneiro.

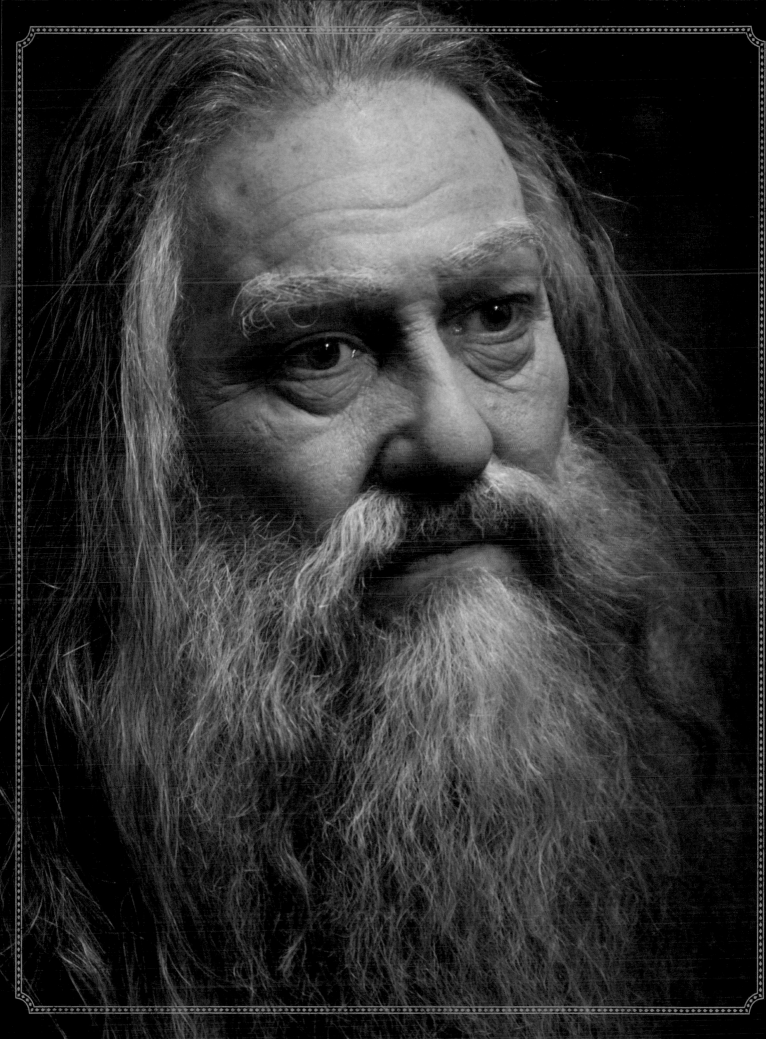

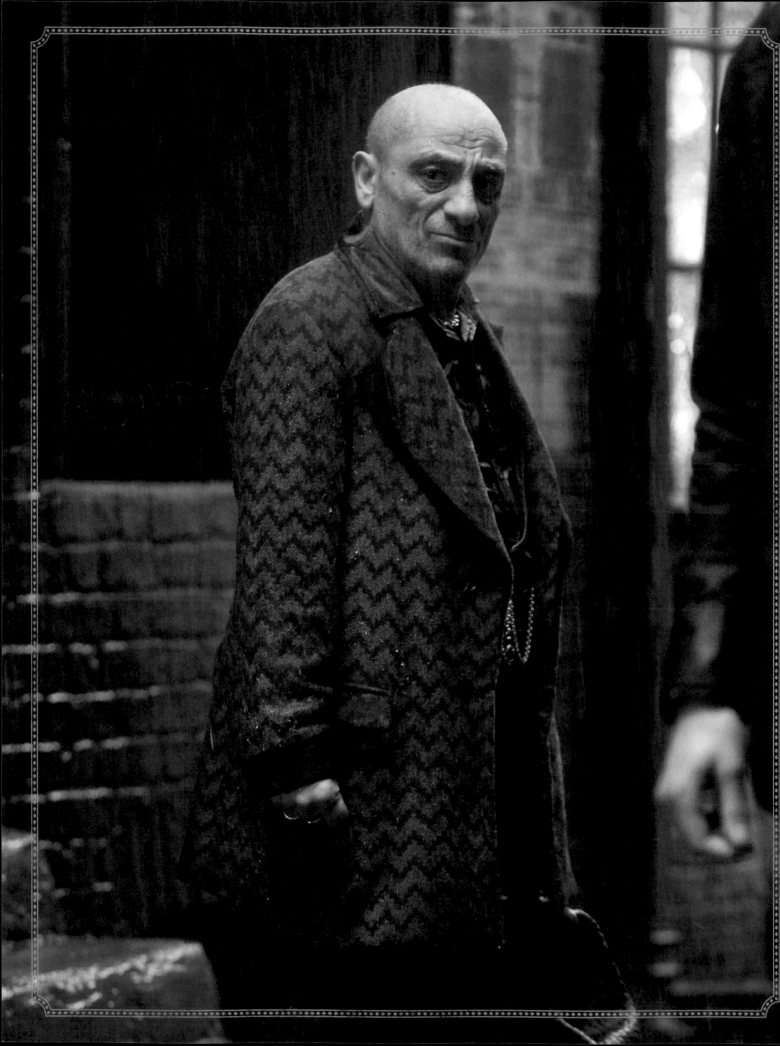

MUNDUNGUS FLETCHER

Actor Andy Linden describes his character, Mundungus Fletcher, as "loosely" being a member of the Order of the Phoenix. "Technically, he was coerced," says Linden. "Reluctantly he's got to go along. He doesn't really want to do this; he'd sooner be out wheeling and dealing. He's not exactly a big fan of Harry's, so he's doing this under duress. And he declares that!" During his one and only appearance, in *Harry Potter and the Deathly Hallows – Part 1*, Mundungus refers to himself as a "purveyor of rare and wondrous objects," but after he's brought to number twelve, Grimmauld Place by the house-elves Dobby and Kreacher, when it's discovered he stole the real Slytherin Locket Horcrux, Ron Weasley reminds him of the truth: "You're a thief, Dung, everyone knows it."

Being a thief, it's not impossible to make the leap that the clothes he wears aren't his own. They're rather stylish for a man of his presumed class, and they don't fit very well. Fortunately, there are myriad pockets in his coat and vest, the better to hide purloined treasure. Linden adds that his own features complemented the look of his character. "I've got a sort of a hangdog look, so it was decided that he would be somewhat disheveled." Mundungus wears an eight-day growth of beard, "and he looks like he hasn't had a bath for a year!" Linden adds.

Portraying a not-quite-heroic character was one thing that attracted the actor to the role. "You tend to find that characters who are immoral are more interesting to play," he explains. "You can work with that nasty little streak of evil about him more than if you're playing the ultimate goody-goody; it's a lot of fun.

"If there's a deal to be done, he wants in on it," he continues. "[David Yates] and I spoke about that. Dung's an opportunist. Not that he'd sell out his mother—or his soul—but he's always looking for that prime opportunity. He is," the actor admits, "a bit of a weasel."

FIRST APPEARANCE:
Harry Potter and the Deathly Hallows – Part 1

OCCUPATION:
"Dealer" of questionably acquired wizard artifacts

MEMBER OF:
Order of the Phoenix

PATRONUS:
Unknown

INSET AND OPPOSITE: Andy Linden as Mundungus "Dung" Fletcher; LEFT: Costume design by Jany Temime, illustration by Mauricio Carneiro; BELOW: Ministry of Magic registration form and identity card for Mundungus, found in Dolores Umbridge's office in *Harry Potter and the Deathly Hallows – Part 1*.

MUNDUNGUS'S WAND

Mundungus does not get much opportunity to use his wand—as soon as he tries to bring it out in a scuffle in the Grimmauld Place kitchen, Hermione casts *Expelliarmus*. Though he's a bit of a lowlife, his thirteen-inch wand is very high-end: It has a golden collar between the pommel and the handle set with a large, black stone. The tip of the pommel also bears a gold decoration of an unidentified horned creature surrounded by a ribbon-like spiral.

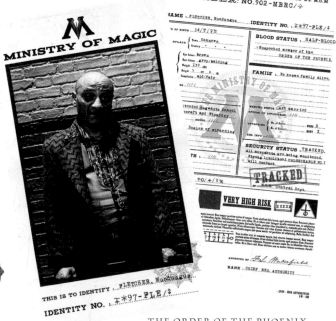

MOLLY & ARTHUR WEASLEY

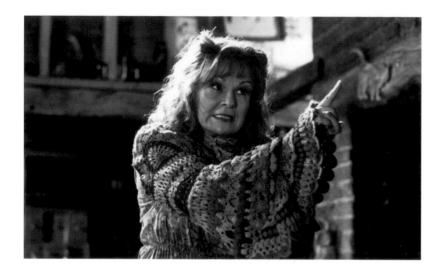

MOLLY WEASLEY

FIRST APPEARANCE:
Harry Potter and the Sorcerer's Stone

ADDITIONAL APPEARANCES:
Harry Potter and the Chamber of Secrets
Harry Potter and the Prisoner of Azkaban
Harry Potter and the Order of the Phoenix
Harry Potter and the Half-Blood Prince
Harry Potter and the Deathly Hallows – Part 1
Harry Potter and the Deathly Hallows – Part 2

HOUSE:
Gryffindor

OCCUPATION:
Mother

MEMBER OF:
Order of the Phoenix

Just as a set designer will consider architectural shapes when creating a set, a costume designer muses on the silhouette of a character. Molly Weasley's silhouette is soft and motherly, "nicely rounded" as actress Julie Walters describes it. But "I was heartbroken on the first film," she states, "when Daniel Radcliffe thought that was all me." The silhouette was initially created not by cotton stuffing or fluffy wadding but by . . . bird seed. "I was admittedly worried while on the King's Cross station set, with the pigeons and the owls." Her concern was well founded, and soon the silhouette was created in a more traditional way. Judianna Makovsky knew that Molly Weasley's silhouette would be covered in "crafty" clothing, as the Weasley's were not as well-off as other wizarding families and would have to "make do," though Molly's first appearance in *Harry Potter and the Sorcerer's Stone* is in her version of Muggle clothing, as she is at King's Cross station.

The Weasleys' wardrobe was among *Harry Potter and the Chamber of Secrets* costume designer Lindy Hemming's favorites. Hemming consulted with production designer Stuart Craig about the look of The Burrow and took her cues from the country-wizard feeling of their home environment. "We knew from the books that Molly Weasley loved knitting, and decided that the Weasley house was probably a bit chilly now and again, and she didn't like ironing, so all their clothes became imbued with a woolly feeling. We went on a woolen tweed adventure!" The wool that was used to create the sweaters and scarves and crochet edging on other clothing items was purchased from vintage wool merchants. Tweeds and corduroys added additional textures and patterns, covered by kitschy aprons, all in the ginger-haired Weasleys' palette of earth tones in greens, oranges, and browns. Molly Weasley's costumes took roughly twelve weeks from start to finish, fitted around the padding Julie Walters wore.

INSET: Mark Williams as the Weasley patriarch, Arthur; TOP: Molly Weasley in one of her homemade creations in *Harry Potter and the Chamber of Secrets*; RIGHT: Molly's coat for *Harry Potter and the Deathly Hallows – Part 2*, sketch by Mauricio Carneiro; OPPOSITE: The actors' warm relationship is evident in a publicity photo of Julie Walters and Mark Williams for *Harry Potter and the Order of the Phoenix*.

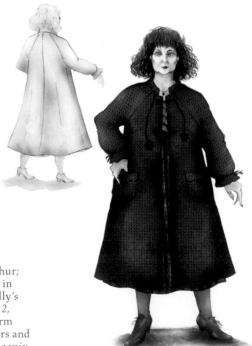

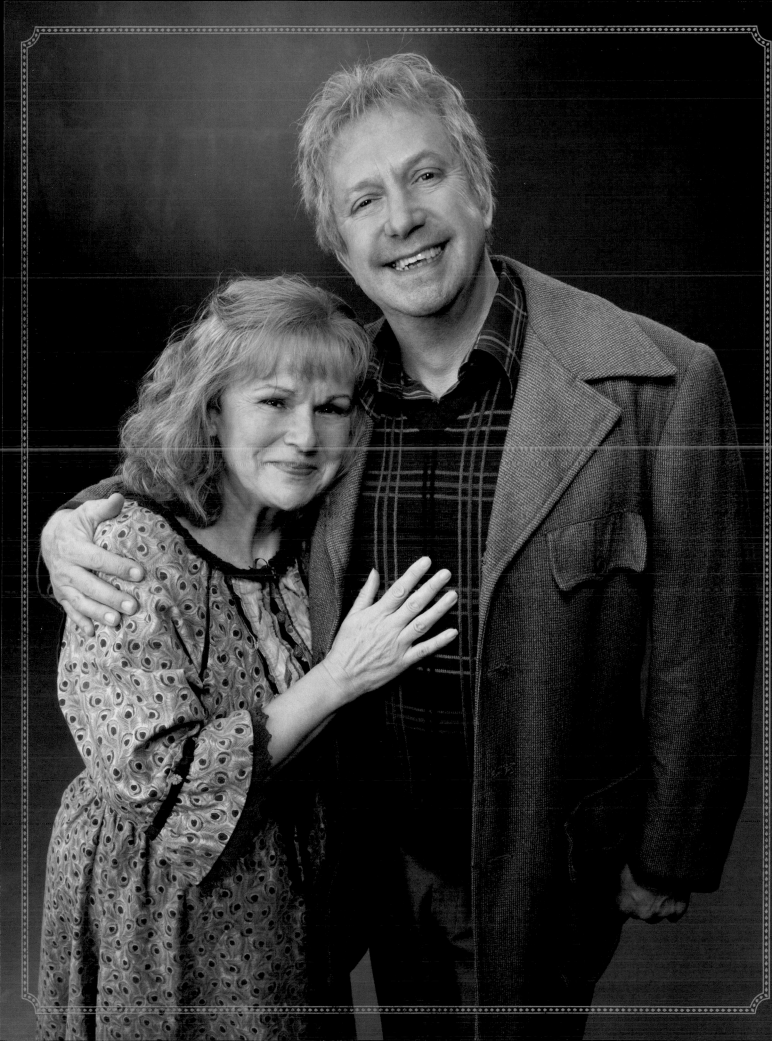

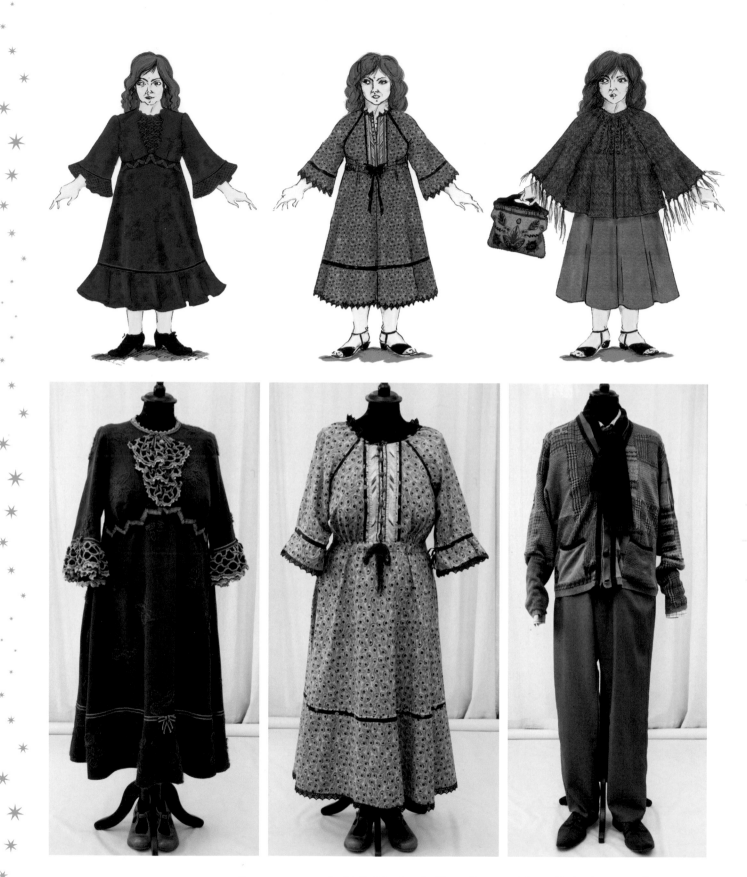

TOP ROW AND ABOVE LEFT AND CENTER: Costume concepts for Molly Weasley for *Harry Potter and the Half-Blood Prince* and *Harry Potter and the Order of the Phoenix* are seen in fully realized forms and in costume reference shots; ABOVE RIGHT: Casual home wear for Arthur Weasley for *Half-Blood Prince* seen in a costume reference shot; OPPOSITE LEFT: Sketch by Mauricio Carneiro; OPPOSITE TOP: Harry and the Weasleys en route to the Quidditch World Cup in *Harry Potter and the Goblet of Fire.*

"Tell me, what exactly is the function of a rubber duck?"

—ARTHUR WEASLEY
Harry Potter and the Chamber of Secrets

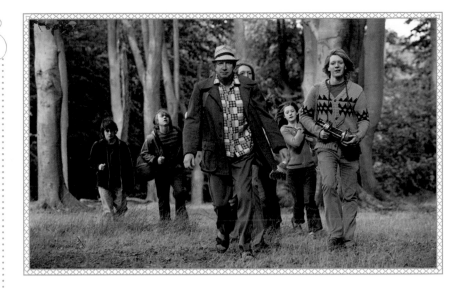

Throughout the course of the *Harry Potter* films, Molly Weasley is "mother first and witch second," says Walters, except in the final battle for Hogwarts in *Harry Potter and the Deathly Hallows – Part 2*. "Normally she is the mother, but for this she is a fighter, and should look so," says Temime. "I was inspired by Spaghetti Westerns again."

Arthur Weasley's clothing took less time to construct. "We tried lots of suits with different old-fashioned shapes, borrowed from a costume house," explains Hemming, "to see how the silhouette would work on him to get an interesting body shape." Coordinating her decisions with associate costume designer Michael O'Connor, the head of the Weasley clan was dressed in a suit based on research into 1950s civil servants' clothing and a wizardy pointed hat was added that would evoke the businessman's Trilby hat of that era. Mr. Weasley's robe is green, which O'Connor felt "would have been like a warehouse or uniform coat that he might have put on at work."

When Jany Temime took over costuming duties on *Harry Potter and the Prisoner of Azkaban*, she continued the Weasley tradition of reusing and renewing. "I think [Molly] recycles everything; she has to because there isn't a lot of money. Many things are second-hand." But Temime considered that Mrs. Weasley has "an amazing imagination. This old bedspread? She will make a coat of it. That dress might have been curtains." For many pieces for the Weasley family, clothing was purchased at contemporary shops and then distressed, altered, and redesigned with different buttons, old lace, and rickrack, and inevitably finished off with something knitted.

MOLLY'S & ARTHUR'S WANDS

Molly Weasley's wand is simple, but as Julie Walters affirms, "I felt like a warrior with it. It was heaven when I first got to use the wand." Walters worked with Paul Harris, the wand choreographer for *Harry Potter and the Deathly Hallows – Part 2*, and found that wielding a wand was quite different from other forms of fighting with arms. "There's nothing to actually hit, so you have a tendency to whack your arm around, which could get painful at the end of the day. Worth it, though. I absolutely loved my battle with Bellatrix."

Arthur Weasley's wand has what prop modeler Pierre Bohanna describes as "a sugar barley twist." The handle of the wand is finely turned, with a Jacobean feel to it. Actor Mark Williams felt his wand was very elegant. "I was quite fond of it," he recalls, "except that I developed a strange posture with it." The right-handed Williams found that he would consistently use his left hand to pick up the wand. "So my choreography became a bit twisted. Well, you can't say I didn't have my own personal style!"

THE NEW ORDER

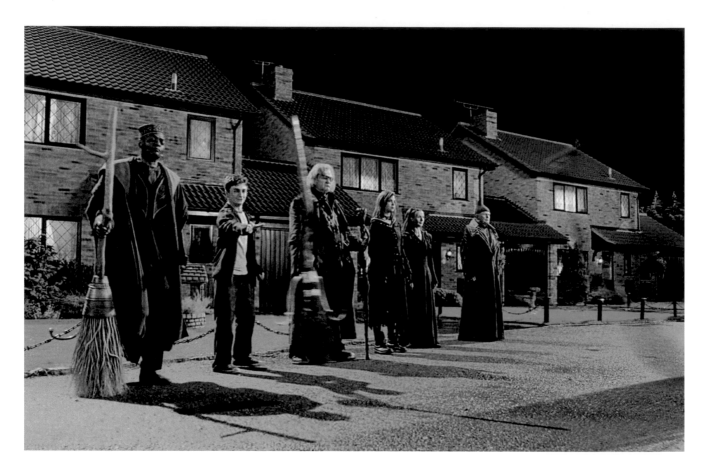

During Harry Potter's time at Hogwarts, a Second Wizarding War began, which brought about a new Order of the Phoenix. As seen in *Harry Potter and the Sorcerer's Stone*, Voldemort had been able to sustain his life through drinking unicorn blood and using the body of Defense Against the Dark Arts Professor Quirinus Quirrell as a host, but he still had no magical powers. Then, deliberate signs of a resurgence of anti-Muggle sentiment arose in the wizarding community after some Death Eaters escaped from Azkaban. As *Harry Potter and the Goblet of Fire* opened, Death Eaters invaded the 422nd Quidditch World Cup, carrying torches and casting hexes under the sign of the Dark Mark in the sky, set there by the *Morsmordre* spell cast by Barty Crouch Jr.

Crouch was also able to perform covert acts on Voldemort's behalf within Hogwarts school, where the Triwizard Tournament was being held. Utilizing Polyjuice Potion, Crouch impersonated that year's Defense Against the Dark Arts professor—former Auror and Order member Alastor "Mad-Eye" Moody. Helping Harry to victory, Crouch turned the Triwizard Cup, which the winner would touch, into a Portkey. This whisked Harry and co-winner Cedric Diggory to the Little Hangleton graveyard where

a ritual on Voldemort's behalf was being held. Once performed, this rite would restore the Dark wizard to a corporeal body with magical abilities, but it required as one of its ingredients the blood from his most hated enemy: Harry Potter. Cedric was killed by Peter Pettigrew, a former Order member who assisted Voldemort in the ritual in the graveyard. Harry survived their encounter and was able to return to Hogwarts and inform Dumbledore that Voldemort was back.

Dumbledore was quick to reestablish the Order of the Phoenix, bringing in new members and establishing a headquarters at the family home of Sirius Black. Kingsley Shacklebolt was an Auror working in the Ministry of Magic who worked undercover to provide Ministry comings and goings. Nymphadora Tonks, the niece of Bellatrix Lestrange, also worked as an Auror and joined the Order. Two reluctant but loyal members of the new Order of the Phoenix were Mundungus Fletcher, a member of the original Order of dubious reputation, and Aberforth Dumbledore, Albus's younger brother. Rubeus Hagrid, Emmeline Vance, Elphias Doge, the real Alastor Moody, and Remus Lupin rejoined. Lupin had gone on to teach Defense Against the Dark Arts at Hogwarts during Harry's third year at the school. Another professor, Severus Snape,

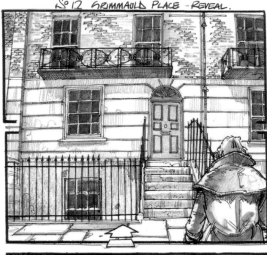

№ 12 GRIMMAULD PLACE - REVEAL.

ANGLE ON GRIMMAULD PLACE AS MOODY MOVES TOWARD HOUSE.

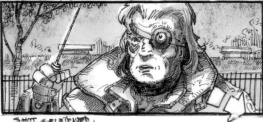

C/U ON MADEYE MOODY

HE PULLS OUT HIS WAND AND CAST SPELL.

SHOT CONTINUED.

CAMERA TRACKS DOWN TO HARRY AS HE WALKS UP TO BE BESIDE MOODY.

SHOT CONT.

HARRY ... MOODY'S SHOULDER.

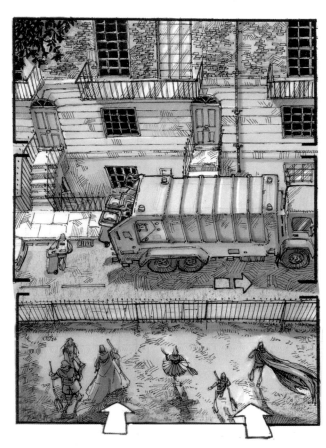

OPPOSITE: The Advance Guard of the Order of the Phoenix escorts Harry away from Privet Drive in *Harry Potter and the Order of the Phoenix*—(left to right) Kingsley Shacklebolt (George Harris), Harry Potter (Daniel Radcliffe), Alastor Moody (Brendan Gleeson), Tonks (Natalia Tena), Emmaline Vance (Brigitte Millar), Elphias Dodge (Peter Cartwright); THIS PAGE: Storyboards illustrate the Order's arrival at number twelve, Grimmauld Place.

clandestinely helped the Order. Some of the first Order's children also joined. Molly and Arthur's sons Fred and George volunteered, along with their oldest brother, Bill, and his wife, former Triwizard Tournament champion Fleur Delacour. Harry, Hermione Granger, and Ron Weasley were unofficial members, as they were considered underage.

In *Harry Potter and the Order of the Phoenix,* Harry learned of the titular Order when it sent an Advance Guard to transfer him safely to their headquarters after Dementors attacked him and his Muggle cousin. The Order later helped Harry invade Hogwarts after Dumbledore was killed and Death Eaters took over the school. In the Battle of Hogwarts, seen in *Harry Potter and the Deathly Hallows – Part 2*, the Order fought valiantly, losing Remus Lupin and his now wife, Nymphadora Tonks, and Fred Weasley during the final confrontation.

NYMPHADORA TONKS

Natalia Tena admits that her first audition for the role of Nymphadora Tonks in *Harry Potter and the Order of the Phoenix* was pretty much a disaster. "I hadn't seen any of the films. I hadn't read any of the books. I didn't know what a Muggle was. I walked into the room and tripped over a chair, and for some reason, I was quite loud." Later that day, her agent called and told her, "Nat, it really *was* awful, but for some reason they want to see you again." After a long audition process, during which Tena read the books and saw the movies that had come out, she landed the part. "I really did love stories with witches. Until I was six, I believed three witches had left me on the doorstep. On my eighteenth birthday, my mother gave me a broom, so perhaps this was meant to be." Director David Yates gave Tena an important note to follow: "Find that twinkle."

Tonks's wardrobe also developed after a long process. Her first look was what Tena describes as "weird eighties punk glamour night," with pointy high heels, striped tights, and a pink tutu. Jany Temime felt that though the character was a bit more rebellious and light-hearted than others, she wanted her to appear strong. A pair of boots was swapped in, along with a long coat, hooded sweatshirt, fingerless gloves, and ripped tights, and Tena saw her character emerge. "The boots made her sturdy," Tena explains, "but they also trip her up. She's trying to act like an adult, but keeps screwing up and falling." A long red coat with military tailoring was worn for the climatic scenes at the Ministry between Death Eaters and the Order of the Phoenix. "She's ready for battle," says Tena, "but she still looks cool." Tonks's hair, pink in the books, was colored purple in order not to conflict with the pink associated with Dolores Umbridge. It turns red, in anger, and at the end of the battle scene, briefly white.

Tonks's flashy warrior togs are in direct contrast to the plain, drab clothes of her future husband, Remus Lupin. But as the Dark forces grow in *Harry Potter and the Half-Blood Prince*, Tonks becomes more serious. Her hair is now brown with a subtle purple rinse, and her clothes show more maturity. "Dark times, dark hair," Tena suggests. For *Harry Potter and the Half-Blood Prince*, Tena is seen in her own hair instead of the purple wig, and her outfits are created with softer textures and muted colors, although the palette stayed the same. "She's in love, and a bit more girly. But she does bring that adult aspect, she has to. She's still wearing those boots. There's just less twinkle." For *Harry Potter and the Deathly Hallows – Part 1* and *Part 2*, Jany Temime designed maternity clothes for Tonks for the Weasley wedding, dressing her in a floating silk fabric.

FIRST APPEARANCE:
Harry Potter and the Order of the Phoenix

ADDITIONAL APPEARANCES:
Harry Potter and the Half-Blood Prince
Harry Potter and the Deathly Hallows – Part 1
Harry Potter and the Deathly Hallows – Part 2

HOUSE:
Hufflepuff

OCCUPATION:
Auror

MEMBER OF:
Order of the Phoenix

ADDITIONAL SKILL SET:
Metamorphagus

TONKS'S WAND

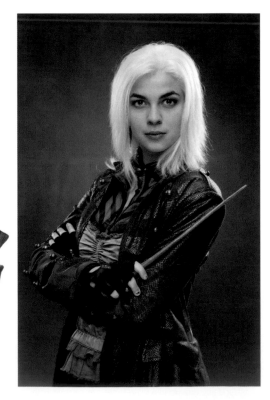

Nymphadora Tonks's wand is thin, with a striped shaft of two different woods. The handle resembles a Jack in the Pulpit flower, with a deep curve that allows for a strong grip on the end, which actress Natalia Tena only realized during the filming of *Harry Potter and the Deathly Hallows – Part 1*. "I thought I had worked out the right way to hold it," she admits. "And even had extensive wand training for *Order of the Phoenix*. But it wasn't until the wedding in *Part 1* that I realized that my wand had a little nook to work with!"

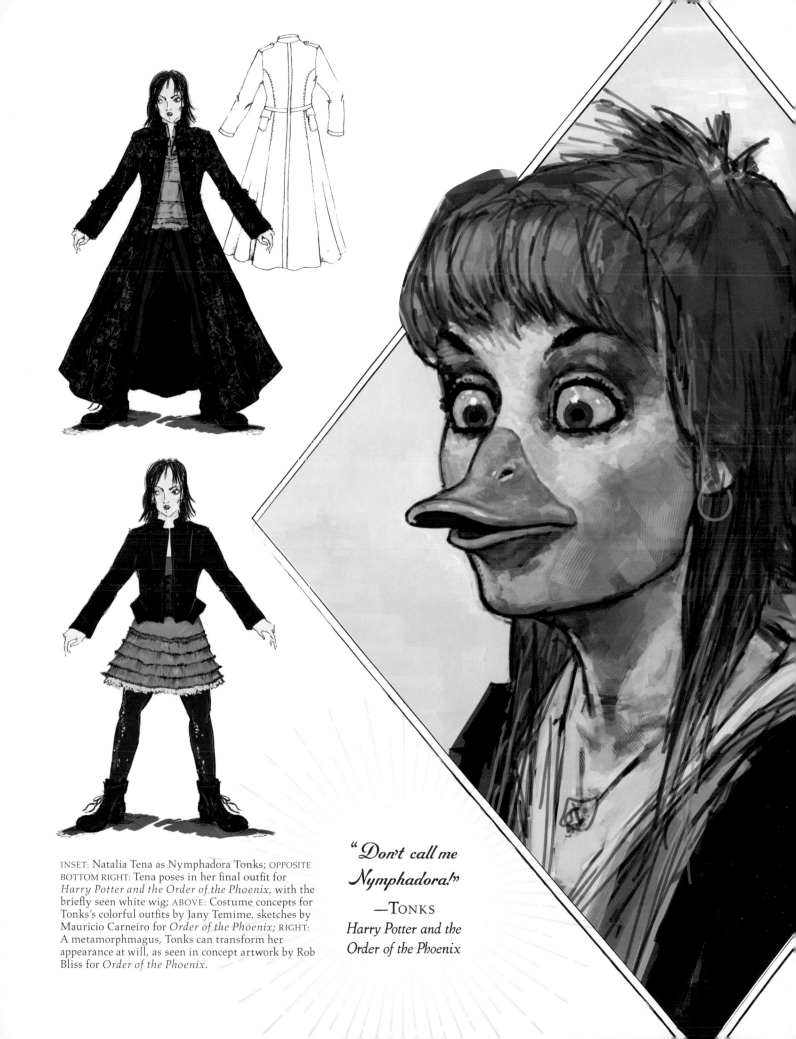

INSET: Natalia Tena as Nymphadora Tonks; OPPOSITE BOTTOM RIGHT: Tena poses in her final outfit for *Harry Potter and the Order of the Phoenix*, with the briefly seen white wig; ABOVE: Costume concepts for Tonks's colorful outfits by Jany Temime, sketches by Mauricio Carneiro for *Order of the Phoenix*; RIGHT: A metamorphmagus, Tonks can transform her appearance at will, as seen in concept artwork by Rob Bliss for *Order of the Phoenix*.

"Don't call me Nymphadora!"

—TONKS
Harry Potter and the Order of the Phoenix

Although it is Kingsley Shacklebolt who comments upon Albus Dumbledore's noticeable style, the Order of the Phoenix member is no slouch when it comes to flair. Actor George Harris was partially instrumental for the look of the character. "I came down to a fitting," recalls Harris, "and I was wearing an Agbada, which is a Nigerian ceremonial gown. Underneath that, I had on a pair of Kota trousers, like Indian pajamas." Jany Temime liked what she saw and decided that not everyone in the Ministry needed to wear a suit. She and Harris built upon the idea and assigned Shacklebolt an African heritage not specified in the books. The heavy Agbada robes he wears are embellished with beads, applique, and embroidery inspired by African motifs, with piping around the border. "I love to wear beads and bangles," he says, "so in addition to the earring that was indicated in the books, I wanted the beads, which make me feel very comfortable."

Shacklebolt's cap is also Nigerian-based. Having filmed in some very cold locations, the bald-headed actor knows that wearing a hat will help keep him warm. "But I also felt that the hat would, in a way, keep Shacklebolt's power from escaping. He has a quiet strength and wants to keep a lid on it." Literally. The hat is created from shot silk, which reflects light differently from different angles, and so shifts its color hues, in this case between blue, purple, and black.

FIRST APPEARANCE:
Harry Potter and the Order of the Phoenix

ADDITIONAL APPEARANCES:
Harry Potter and the Deathly Hallows – Part 1
Harry Potter and the Deathly Hallows – Part 2

OCCUPATION:
Auror, personal bodyguard to Muggle Prime Minister, temporary Minister for Magic

MEMBER OF:
Order of the Phoenix

PATRONUS:
Lynx

SHACKLEBOLT'S WAND

Kingsley Shacklebolt's wand is a combination of several woods put together with a very organic structure in their design. Actor George Harris felt that though his character's costume is "flashy, he wouldn't have any big flashy wand moves. Economy is very, very important in the Order. His tendency is to be quite quick and very effective."

"You may not like him, Minister, but you can't deny Dumbledore's got style."

—KINGSLEY SHACKLEBOLT
Harry Potter and the Order of the Phoenix

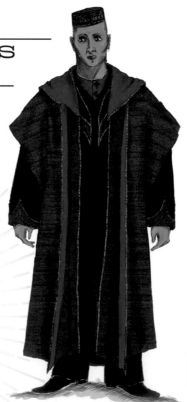

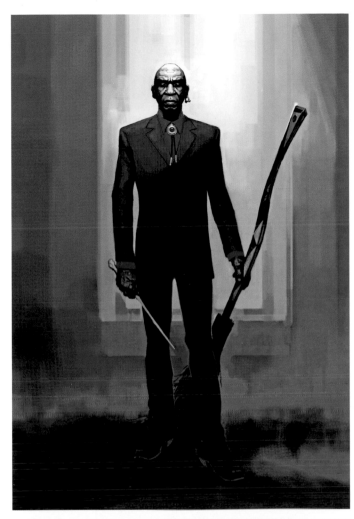

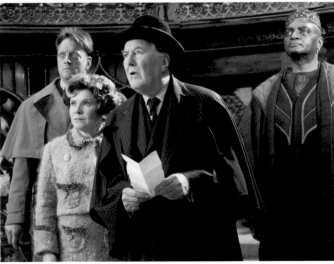

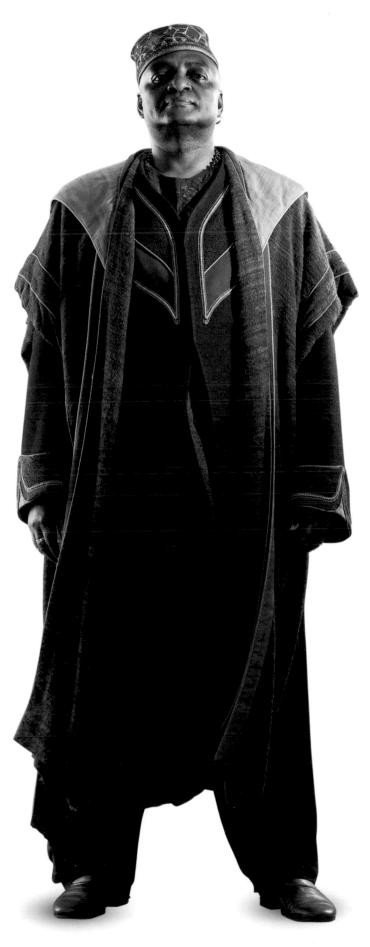

INSET: George Harris as Kingsley Shacklebolt; OPPOSITE BOTTOM CENTER: Jany Temime's sumptuous design for Shacklebolt's robes, sketch by Mauricio Carneiro for *Harry Potter and the Order of the Phoenix*; OPPOSITE BOTTOM RIGHT: Fabric samples showing embroidery details; TOP: An early concept drawing of Shacklebolt by Rob Bliss; ABOVE: In Dumbledore's office with Auror John Dawlish (Richard Leaf), Dolores Umbridge, and Minister for Magic Cornelius Fudge (Robert Hardy); RIGHT: As with Dumbledore, you've got to admit that Shacklebolt has style.

THE ORDER IN MOTION

I n *Harry Potter and the Deathly Hallows – Part 1*, Harry is again helped by the Order when he leaves his Muggle family's home on Privet Drive to fight against Voldemort and his Death Eaters. Because he is still underage, he has the Trace on him—a charm the Ministry of Magic places on young wizards to keep track of underage magic outside of Hogwarts. So, a way must be devised to thwart the Ministry's surveillance as well as confuse any of Voldemort's Death Eaters who might attack. In order to achieve this subterfuge, Alastor Moody comes up with a plan: Instead of one Harry, there will be seven Harrys, who will travel in pairs, flying on brooms and Thestrals, with one in the sidecar of Hagrid's motorbike. "The name of the game is confusion," says Brendan Gleeson (Alastor "Mad-Eye" Moody). "Mad-Eye may be a bit daft, but he's a force to be reckoned with. He's a man of limited sentimentality, but there is a certain poignancy to the fact that beneath his gruff exterior, his heart has always been in the right place."

Moody assembles the volunteers and passes around a flask of Polyjuice Potion. Within seconds, Fred, George, and Ron Weasley, Hermione Granger, Fleur Delacour, and Mundungus Fletcher are transformed into Harry Potter. This computer-generated

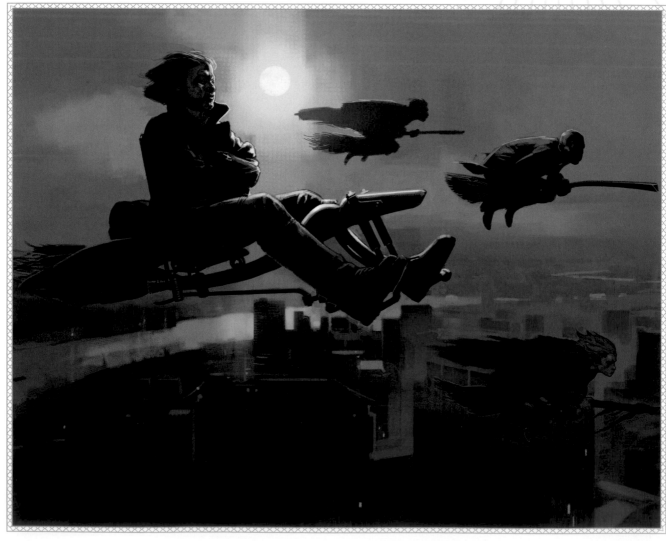

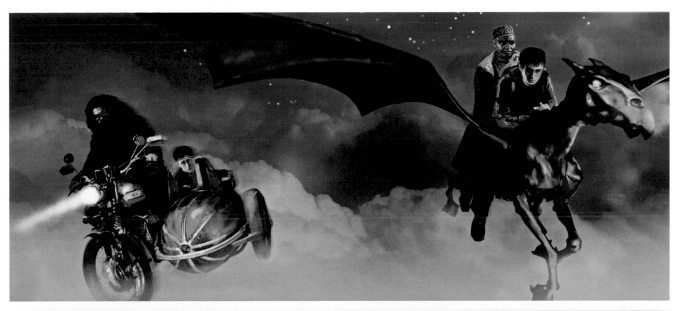

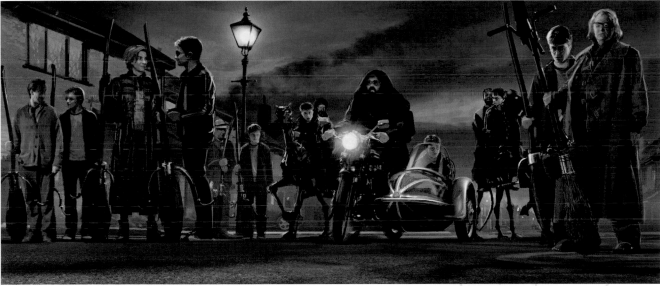

effect was one of the most complex in the film, involving layer upon layer of live-action and CG animation composited together resulting in the multiple Harrys. First, each of Harry's impersonators was filmed reacting to the vile taste of the Polyjuice Potion using facial expression motion capture technology that used an ultraviolet makeup. Then Daniel Radcliffe reenacted the other actors' performances wearing the costumes worn by each character. "The Polyjuice Potion transforms them into Harry on the outside," says Radcliffe, "but it doesn't change who they really are, so I had to do a bit of impersonation of the other characters." According to visual effects supervisor Tim Burke, "The amount of detail he incorporated was incredible—proving that he knew the others very well."

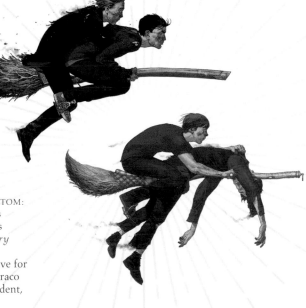

OPPOSITE TOP: Designs for multi-rider brooms by Adam Brockbank; OPPOSITE BOTTOM: Members of the New Order fly over London in art by Brockbank. Alastor Moody's broom rig resembles a motorcycle; TOP: The real Harry Potter rides with Hagrid as Kingsley Shacklebolt and the Polyjuice-Potioned Hermione fly by Thestral in *Harry Potter and the Deathly Hallows – Part 1*. Art by Andrew Williamson; MIDDLE: Williamson portrays the Order and six disguised Harrys before leaving Privet Drive for The Burrow; RIGHT: Concept art, by Adam Brockbank, of Harry Potter rescuing Draco Malfoy and, by Andrew Williamson, of Ron Weasley rescuing an unidentified student, both for *Harry Potter and the Deathly Hallows – Part 2*.

Director David Yates had each of the actors play out the scene so Radcliffe could observe them, which led to some interesting affectations. "For example, we discovered that Andy Linden, who plays Mundungus, walks as if he's on skis," says Yates, "so I asked Dan to exaggerate that slightly. Normally, I prefer actors to look for the truth—be natural and the camera will find the performance. But in this instance, I realized it would be more playful to push it. So, the truth took a backseat. I think Dan really enjoyed that."

Each character's pass needed at least ten takes, so there were at minimum seventy takes for each shot. "I think I broke the record for most number of takes ever done for a scene, because it all counts as the same shot," says Radcliffe. "We'd shoot one version with me as one of the characters, and then the camera would stay in exactly the same place, and we'd shoot another version with me as another character. Eventually they'd lay them on top of each other. Each pass I did, whether Fleur or Mundungus, was part of one shot, and I think we got up to ninety-five takes!" Radcliffe was most pleased about how good he looked while wearing Fleur Delacour's costume. "It had a

sort of glam rock feel to it," he says with a laugh. "Well, at least that's what was going on in my head, and that's what everyone told me to keep me sweet on set."

Cinematographer Eduardo Serra utilized a motion-control rig to capture multiple passes as Radcliffe portrayed each of Harry's doubles, filmed in very specifically blocked spots on set. Then the passes were layered together in the computer. The first combination of this live-action footage showed the members of the Order changing into Harry, but with no character delineation, just overlapping arms and legs. Digital doubles were animated according to the live-action footage, and then the visual effects crew refined the way each character morphed into Harry. "While they are actually transforming, they're fully computer-generated versions," Burke explains. The digital doubles were created from life casts of the actors, which captured details as fine as beard stubble and eyelashes. This level of attention was crucial—even the characters' blinks had to be synced during the transformations, because if the timing was off even a little, the digital work would be noticeable. When finished, seven Harry Potters occupied the Dursley's living room at the same time.

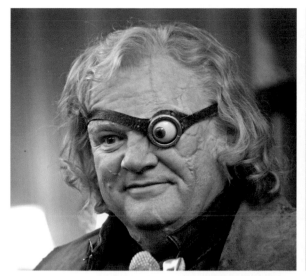

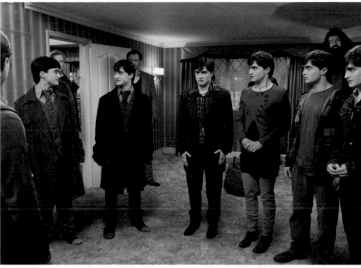

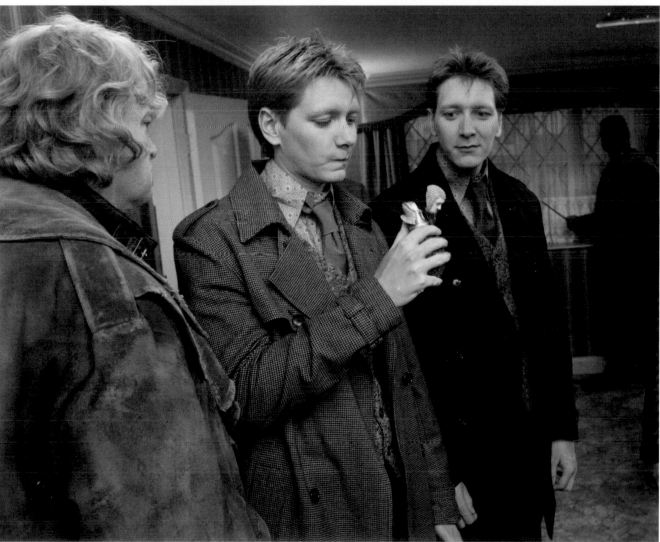

OPPOSITE TOP: Harry Potter (Daniel Radcliffe) learns about the Order of the Phoenix in the kitchen of number twelve, Grimmauld Place in *Harry Potter and the Order of the Phoenix*; TOP LEFT: Alastor Moody (Brendan Gleeson) explains how Polyjuice Potion will provide camouflage to transport Harry to The Burrow in *Harry Potter and the Deathly Hallows – Part 1*; TOP RIGHT: The results of the Polyjuice Potion: seven Harrys; ABOVE: Before transformation, Moody passes around the potion vial starting with Fred and George Weasley (James and Oliver Phelps).

CHAPTER 2
DARK FORCES

LORD VOLDEMORT

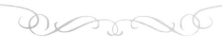

FIRST APPEARANCE:
Harry Potter and the Sorcerer's Stone

ADDITIONAL APPEARANCES:
Harry Potter and the Chamber of Secrets
Harry Potter and the Goblet of Fire
Harry Potter and the Order of the Phoenix
Harry Potter and the Half-Blood Prince
Harry Potter and the Deathly Hallows – Part 1
Harry Potter and the Deathly Hallows – Part 2

HOUSE:
Slytherin

OCCUPATION:
Dark Lord

ADDITIONAL SKILL SET:
Parseltongue

Lord Voldemort had been seen in fleeting glimpses or flashbacks for the first few Harry Potter films. In *Harry Potter and the Sorcerer's Stone*, the noncorporeal He Who Must Not Be Named shares his body with Defense Against the Dark Arts Professor Quirrell. Actor Ian Hart's face and voice were refashioned digitally to create the Dark wizard. Voldemort's first corporeal appearance comes in *Harry Potter and the Goblet of Fire*, where he is "reborn" through a ritual performed by Peter Pettigrew, and much discussion took place as to what the fully realized Voldemort would look like. When Ralph Fiennes was cast in the role, he was shown concept art of the character. "They'd taken photographs of me and morphed them into this frightening, reptilian-looking creature," Fiennes remembers. "That's pretty much when I thought, 'Oh, this would be cool to do!'"

Early designs had Voldemort wearing robes similar to ones seen in a flashback in *Harry Potter and the Sorcerer's Stone*. "I was initially handed this great, thick, black, heavy thing that just didn't work at all," Fiennes says. So Jany Temime took her cue from the rebirth of the Dark Lord. "He is newborn," she explains. "He has just gotten back his skin, so I thought his robe should be a second skin to him, like a membrane. We needed something very tactile, and simple and floaty." Temime also felt that the actor shouldn't be encumbered. "He has such wonderful arms, such expression when he walks. That should be seen." Producer David Heyman felt the same way. "It was important that he wasn't weighed down and that it wasn't ornate. The Death Eaters may enjoy the jewels and finery, but not Voldemort. He's renounced all that." But as Voldemort gains more substance, he gains more layers of silk for his

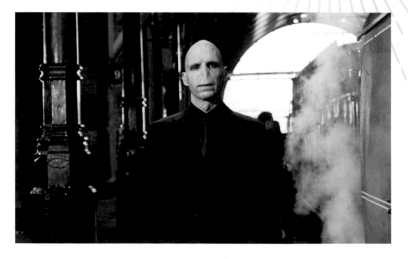

PAGE 38: A Death Eater as imagined for *Harry Potter and the Order of the Phoenix* by artist Rob Bliss; INSET: Ralph Fiennes as Lord Voldemort; LEFT: Voldemort's robes designed by Jany Temime for *Order of the Phoenix*, sketch by Mauricio Carneiro; ABOVE: In a controversial scene in *Order of the Phoenix*, Harry sees Voldemort in Muggle clothes at King's Cross station; OPPOSITE: Voldemort flanked by a Death Eater and Severus Snape at Malfoy Manor in *Harry Potter and the Deathly Hallows – Part 1*.

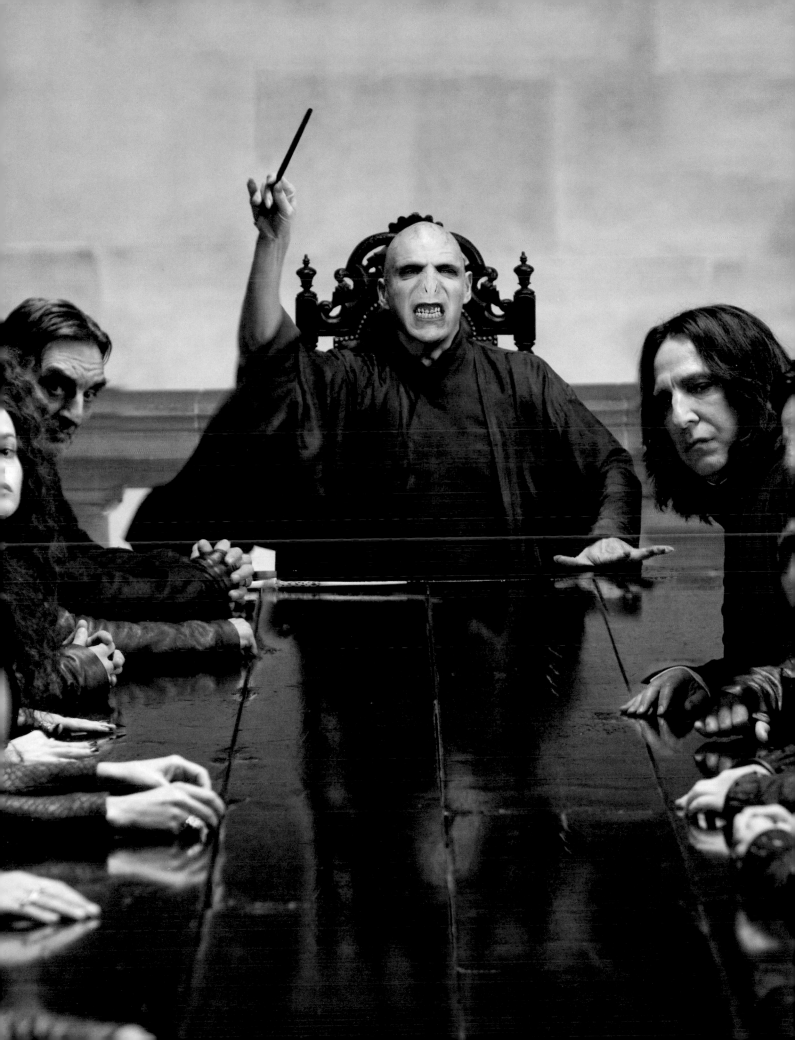

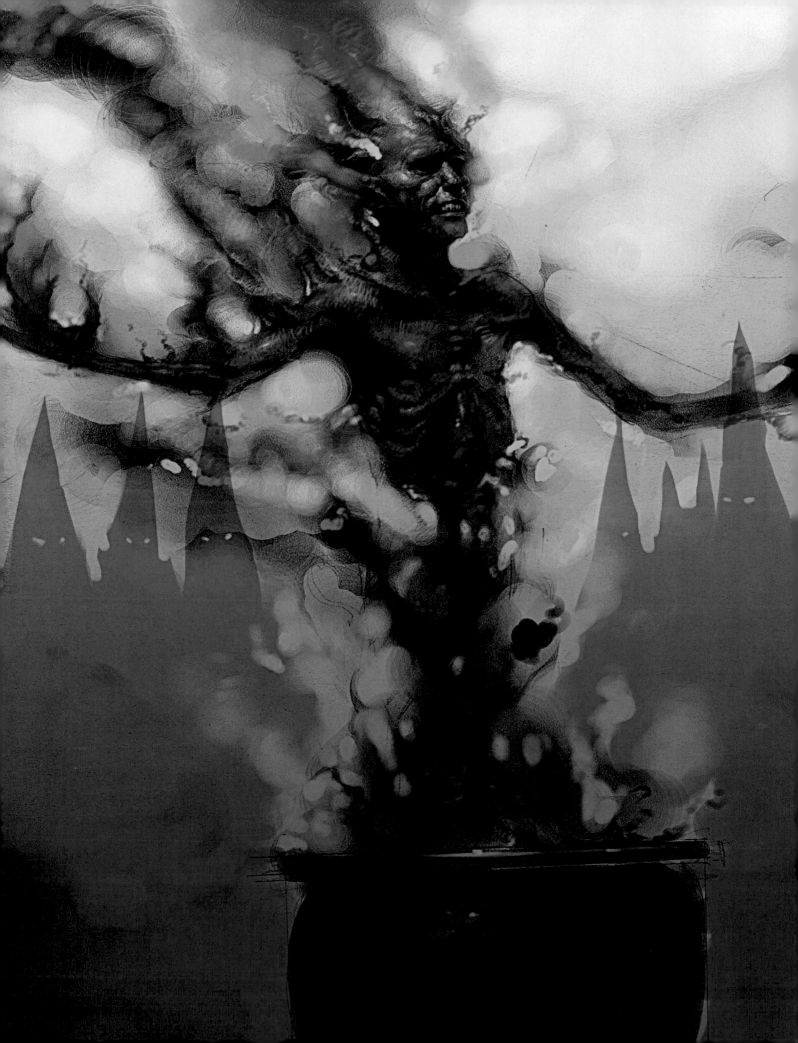

robes. "He is more *there*," says Temime. "So every time he gains new strength, more layers of silk were added." By the time Voldemort appears in *Harry Potter and the Order of the Phoenix*, in his battle against Dumbledore in the Ministry, Fiennes is dressed in more than one hundred and sixty-five feet (fifty meters) of silk.

A most important consideration was the reptilian facial features that Voldemort exhibits. "When we began designing Voldemort," recalls Nick Dudman, "we knew that we wanted him to be bald. Fortunately, Ralph Fiennes agreed to shave his head, because a bald cap is not only the most obvious effect, I think, it would have added two more hours in the makeup chair." Dudman and his conceptual artists felt that Voldemort's skin should have a translucent quality, showing all the veins. "We started with the idea of airbrushing them on, and we convinced one of the crew who was bald to be a test case for the technique. But this would have had the actor standing for up to six hours for the air brushing." Dudman credits key prosthetic makeup artist Mark Coulier with coming up with an idea that saved them all. "Mark suggested that we could create the same effect by copying the air-brushing design onto paper in sections and make them into transferable tattoos. These would line up and link together over his whole head. And we could add tiny dots on them that would line up with the registration points on Ralph's head, neck, and shoulders, so there would never be a problem with continuity. Brilliant." The transfers were produced on a clear material that has a slight sheen to it, which added to the "clammy, creepy, unhealthy" look of Voldemort's skin.

The filmmakers were very pleased with the look of the skin, but producer David Heyman was adamant about recreating Voldemort's snakelike, slit nose. They had already made a concession about not using contact lenses for Voldemort's red eyes. "We wanted to really feel and get into Ralph's eyes," says Heyman, "to really dig deep into Voldemort's. With red eyes, you're drawn more to the redness than you are by the lack of emotion behind them." Nick Dudman experimented on a life cast, chopping off the nose and sculpting a flattened face that was then cyber-scanned and digitally morphed to Fiennes's face. The effect worked to Heyman and the other filmmaker's satisfaction, but then the challenge was how to actually do it. "You could not do it with a prosthetic," avers Dudman. "It would look like a muzzle, and would take away part of the actor's face." It was obvious the effect had to be done digitally—and frame-by-frame. "But by doing this, he didn't have to act through a mask, which was the fear." Fiennes was grateful for the decision. "It's the sort of part where you are easily tempted to cover an actor," he says. "Prosthetics block the expression when you wear all that stuff. They put pieces on to cover my eyebrows, but I wear nothing around my mouth or neck, so the muscles of my face were not held back by too much stuff stuck onto them. I would prefer to do it just by the energy and through the acting of it, rather than through how it looks. Having said that, I would think everyone was very pleased." Having unrestricted movement was a boon to the actor, significantly when he first populated his new body. "We see him touching, feeling his head, feeling his face, feeling how a muscle might move, or what it's like to walk again—testing this whole new body for the first time." Voldemort's look was completed from head to toe. "It just didn't feel right that he would have shoes on," Fiennes continues. "He's just come out of this cauldron. So they gave me these feet with claws." Dudman also gave him false teeth, which lowered his gum line and "made his teeth just nasty," he says. "So you've got the character as described in the books, but it was still very much Ralph. Because, you know, I've always believed if you hire somebody like him, you don't make him invisible cause that's what you're paying for!"

In *Harry Potter and the Deathly Hallows – Part 2*, as the Horcruxes are destroyed, Voldemort's appearance subtly changes. "Voldemort's soul reduces as we watch," explains Dudman. "He becomes more hollow-eyed. His skin starts to crack and he develops little lesions. He literally breaks down."

Eye Ideas 1

HP4 PC 296b

Blood shot

grey/green

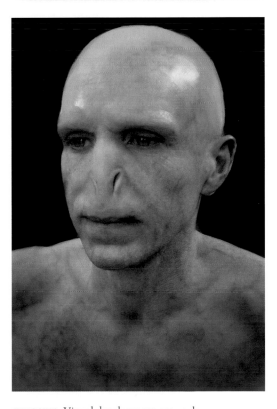

OPPOSITE: Visual development artwork by Paul Catling entitled "Voldemort rising"; TOP AND ABOVE: Digital ideas for Voldemort's eyes and nose, also by Paul Catling, all for *Harry Potter and the Goblet of Fire*.

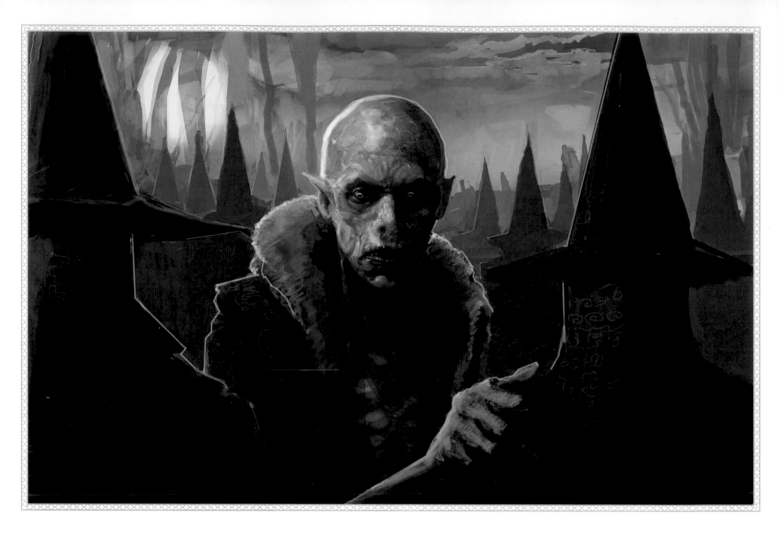

VOLDEMORT'S WAND

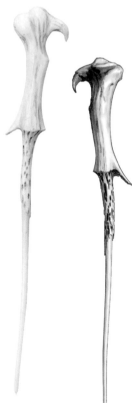

"What I had in mind for Lord Voldemort's wand," says concept designer Adam Brockbank, "was that it was probably carved from a human bone. So you've got this fine, tapering, sharp design. And you can see the honeycomb of the bone in the end section, which comes to the top of the bone, the joint, and then there's a hook on the end, like a claw. It's like a bony, evil finger." Actor Ralph Fiennes had a very distinctive way of holding the wand. "He never holds it like everyone else does," observes Pierre Bohanna. "It's always at the tips of his fingers. It's a very sensitive instrument, as far as he's concerned, so he's always holding it out, and it's always above his head, but it's always at the tips of his fingers."

TOP: Voldemort surrounded by Death Eaters, by Paul Catling, for *Harry Potter and the Goblet of Fire*; OPPOSITE: Early visual development artwork of Lord Voldemort for *Harry Potter and the Sorcerer's Stone*; RIGHT: The fully corporeal Voldemort's first face-to-face confrontation with Harry Potter in *Goblet of Fire*; special effects have not yet removed Fienne's nose and altered his skin; LEFT: Concept artwork of Voldemort's wand by Adam Brockbank.

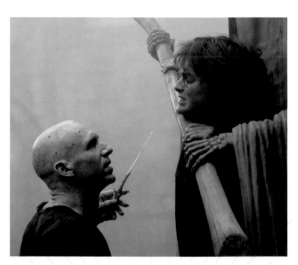

"Harry Potter, the boy who lived . . . come to die."

—VOLDEMORT
Harry Potter and the Deathly Hallows — Part 2

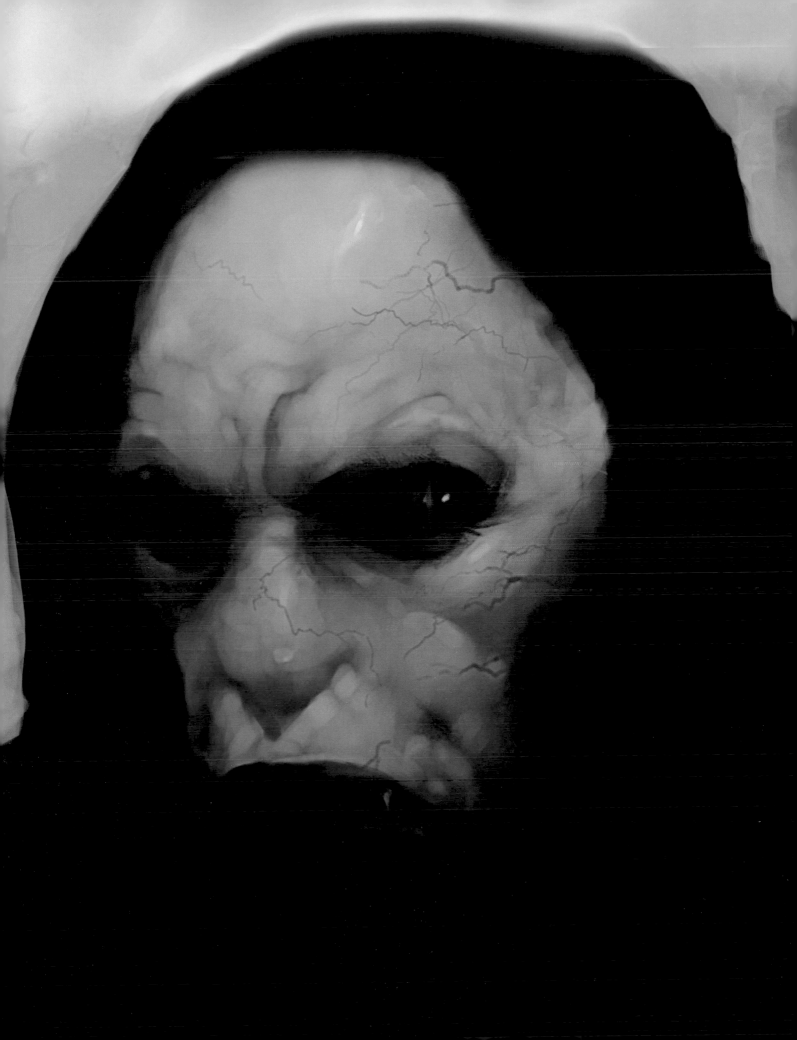

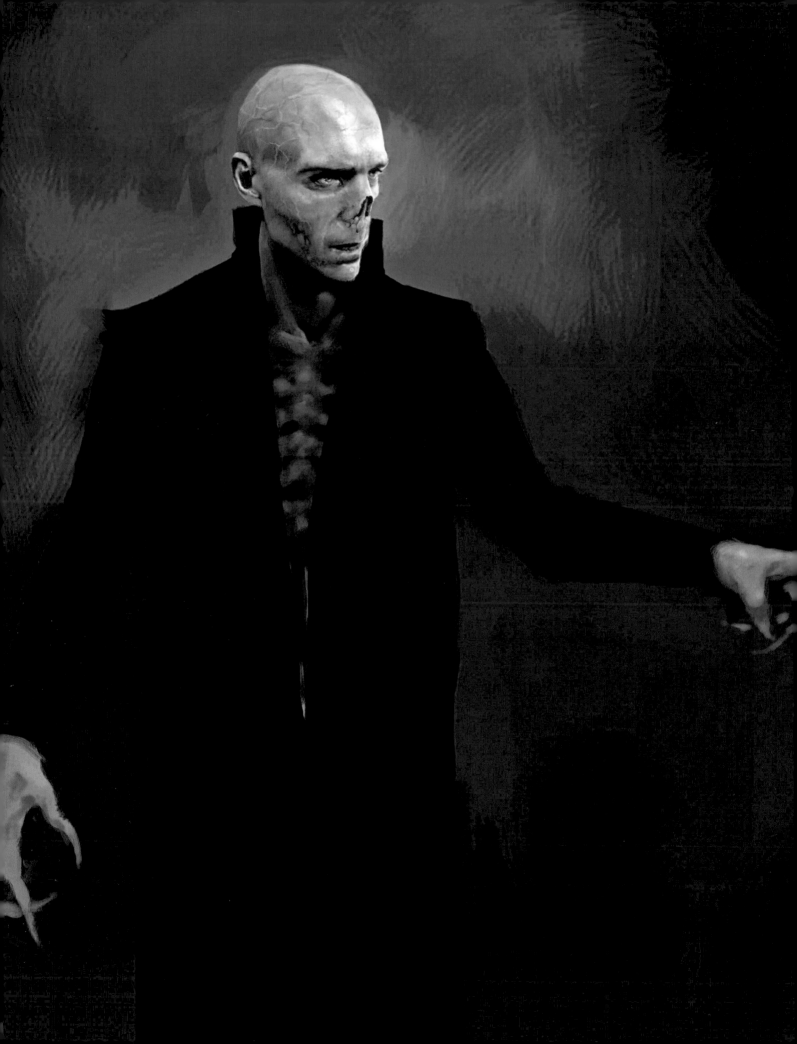

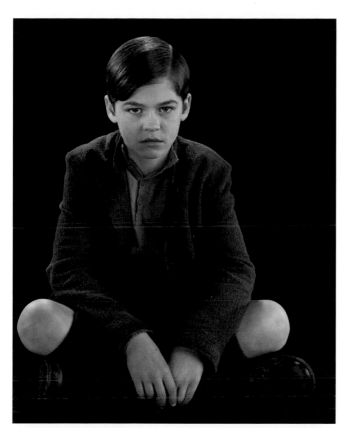

TOM MARVOLO RIDDLE

Voldemort is seen in his younger incarnation, Tom Marvolo Riddle, in several of the films. Christian Coulson played Tom as a teenager from fifty years earlier, in *Harry Potter and the Chamber of Secrets*, wearing school robes with a two-piece suit jacket underneath. The youngest version of Tom was seen in *Harry Potter and the Half-Blood Prince*, when he meets Dumbledore for the first time. Riddle is living at an orphanage, and so Jany Temime dressed actor Hero Fiennes-Tiffin (Ralph Fiennes's nephew) in a nineteenth-century institutional-style outfit of gray shorts, gray socks, gray shirt, and gray jacket. Frank Dillane took over as the teenage Riddle in the same movie, as a student of Horace Slughorn. Dillane required the most makeup work of the three, needing blue contact lenses to match the color of Fiennes's eyes, pale pancake makeup to lighten his skin, and a brunette wig.

OPPOSITE: A black-coated Voldemort envisioned by Paul Catling for *Harry Potter and the Goblet of Fire*; THIS PAGE: Tom Riddle's early years before and at Hogwarts were played by (left) Hero Fiennes-Tiffin at age eleven, in a publicity photo for *Harry Potter and the Half-Blood Prince*, and (bottom left) Frank Dillane at age sixteen, in *Half-Blood Prince*; BELOW: Costume sketches by Mauricio Carneiro for *Half-Blood Prince*.

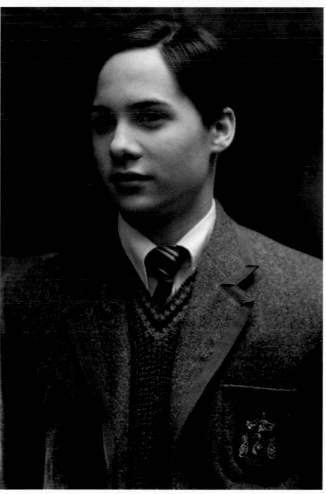

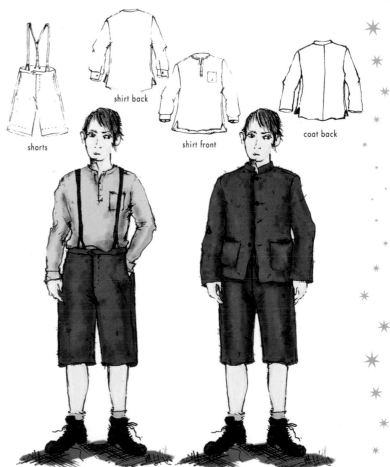

shorts

shirt back

shirt front

coat back

PETER PETTIGREW

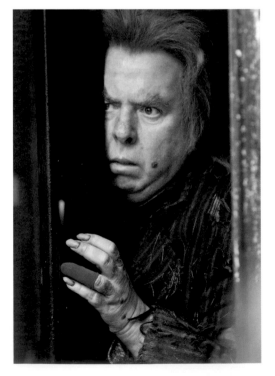

"Peter Pettigrew is a very shrewd, cowardly, weak, conniving, audacious, lying little character that is always ready to save his own skin. Apart from that, he's very nice and rather handsome," says Timothy Spall, who plays the human form of the rat known as "Wormtail" to the Marauders and "Scabbers" to the Weasley family. "This is a man who's been a rat for the last thirteen years," explains *Harry Potter and the Prisoner of Azkaban* director Alfonso Cuarón. "And so he still has to behave and look like a rat." Spall "went for it," continues Cuarón. "His ears were pointy and had hair in them. Then I said, let's have a lot of hair coming out of your nose and let's add two big teeth in the front and have hair on your knuckles." The director found this all delightfully creepy. Of course, Spall was given long fake incisors and, "Since he uses his hands to express his character, we put on very nasty nails that were like little claws," says Amanda Knight. Along with Eithne Fennell, the hair and makeup artists also tried to invoke the various rats who played Scabbers, whether real or animatronic, in their vision for Pettigrew. "We tried to get the texture and the color of Wormtail's wig to match the Scabbers rat," explains Fennell. "We gave him bald patches and scaly skin."

"You are not born a rat," Jany Temime explains. "You have to *become* the rat. So what he wore needed to make him *feel* like a rat." Temime was able to work with the early seventies look of the Marauders for Pettigrew's clothing, allowing that the shape of that style was easily adaptable. Pettigrew's suit had a high collar that truncated his neck so it was barely visible, and the actor wore high-heeled Cuban boots that raised him up as if he was tip-toeing on paws, to give him the illusion of shortened lower legs. His striped jacket and pants combo were made of a fuzzy woolen fabric that was given a silvery sheen to mimic fur. Calculated rips and holes in the material give a fringed effect, and Temime made sure that a good clump of fringe was placed at the back so it almost appears as if he has a tail. Timothy Spall wore a blue-screen material on his "missing" finger for his first appearance in *Prisoner of Azkaban*; for *Harry Potter and the Goblet of Fire* and *Harry Potter and the Half-Blood Prince*, after he cuts off his right hand, the silver replacement was a combination of digital and practical effects.

FIRST APPEARANCE:
Harry Potter and the Prisoner of Azkaban

ADDITIONAL APPEARANCES:
Harry Potter and the Goblet of Fire
Harry Potter and the Order of the Phoenix
Harry Potter and the Half-Blood Prince
Harry Potter and the Deathly Hallows – Part 1

HOUSE:
Gryffindor

OCCUPATION:
Rat

MEMBER OF:
Order of the Phoenix, Death Eaters

ADDITIONAL SKILL SET:
Animagus ("Wormtail," a rat)

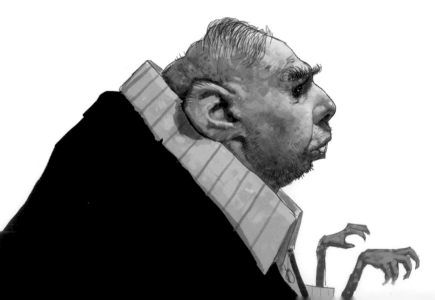

"Ron! Haven't I been a good friend?
A good pet? You won't let them give
me to the Dementors, will you?
I was your rat . . ."

—PETER PETTIGREW
Harry Potter and the Prisoner of Azkaban

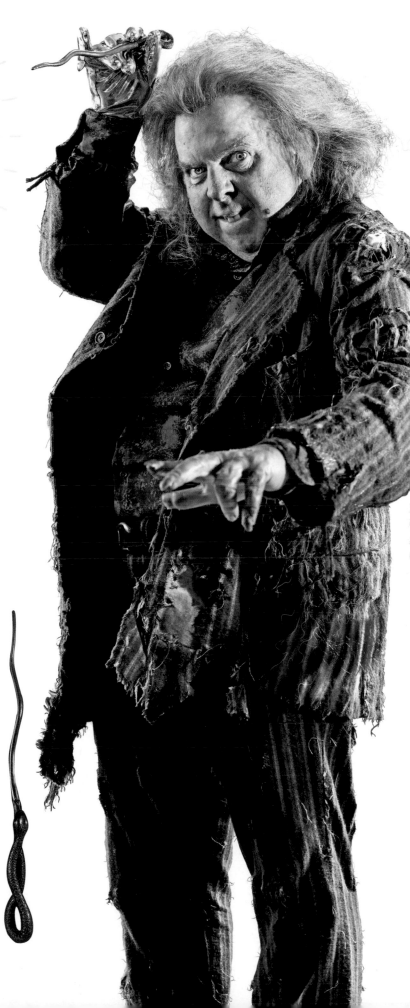

PETTIGREW'S WAND

Prop modeler Pierre Bohanna describes the design of Peter Pettigrew's wand as "Essentially a snake turning back on itself. Its head is on the handle, facing toward its tail, the tail being the tip of the wand." The original casting was carved from a piece of ebony wood. "The wand is supposed to be an extension of your character," says Adam Brockbank. "It must have been an interesting moment for the actors when they first picked up their wand."

INSET: Timothy Spall as Peter Pettigrew; OPPOSITE RIGHT: Pettigrew in *Harry Potter and the Half-Blood Prince,* before special effects removed his (blue-screened) finger; ABOVE LEFT AND OPPOSITE BOTTOM: Pettigrew in various stages of transformation into Scabbers the rat, by Rob Bliss for *Harry Potter and the Prisoner of Azkaban;* ABOVE CENTER: Wormtail's suit for *Prisoner of Azkaban,* sketch by Laurent Guinci; RIGHT: Spall strikes a rodent-like pose in a publicity photo for *Half-Blood Prince.*

BELLATRIX LESTRANGE

It was imperative to actress Helena Bonham Carter that her character of Bellatrix Lestrange look sexy. "I've done witches before and I've done the hag look and I thought for this I want to be sexy." Bonham Carter reasoned that even though Bellatrix had been in Azkaban prison for fourteen years, "She had once been intensely glamorous but has sort of gone to seed." Bellatrix is seen briefly at first in *Harry Potter and the Order of the Phoenix* in a sack-like Azkaban prisoner uniform, but for her next appearance, Bonham Carter worked with Jany Temime to give Bellatrix a curvy shape. Bellatrix's dress, from a time before she went to prison, "may have once been beautiful," says Temime, "but now it's ragged and damaged. Of course, it had to be an old but chic rag." Threads hang down from its hem, laces are twisted, and the fit is a bit off. The waist of the dress, which is embroidered with silver spirals, is cinched in by a thin leather corset that is haphazardly stitched.

The dress was so delicate that it couldn't be washed, so six copies needed to be made just for Helena Bonham Carter.

It is Bellatrix's hair and makeup that exemplify the true twisted nature of the Death Eater. Makeup artist Amanda Knight consulted with Bonham Carter about her look. "Helena wanted to have rotten teeth and nasty nails that were long and gnarled," she recalls. "I remember her painting bags underneath her eyes and sinking her cheeks to make herself look evil and nasty—but then counteracting that with lots of eye shadow, dark lipstick, and loads of mascara and eyeliner." Bellatrix's hair, a mixture of dreadlocks, curls, and way too much teasing is, as Bonham Carter describes it, "conspicuous." Bellatrix was also outfitted with several silver jewelry pieces that echo her gaunt, predatory air: She wears rings of a bird's skull and a bird's claw clutching her thumb, and a pendant with the same bird skull.

Bellatrix's first appearance in *Harry Potter and the Half-Blood Prince* is with her sister Narcissa as they arrive in a rainstorm at the family home of Severus Snape.

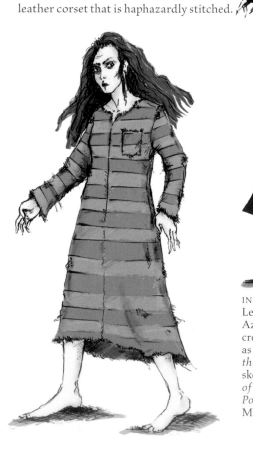

INSET: Helena Bonham Carter as Bellatrix Lestrange; OPPOSITE AND RIGHT: Bellatrix's Azkaban prison photo and a wanted poster created by the graphic arts department, as seen in *Harry Potter and the Order of the Phoenix*; LEFT AND ABOVE: Costume sketches of Bellatrix's prison garb for *Order of the Phoenix* and a hooded coat for *Harry Potter and the Half-Blood Prince*, both by Mauricio Carneiro.

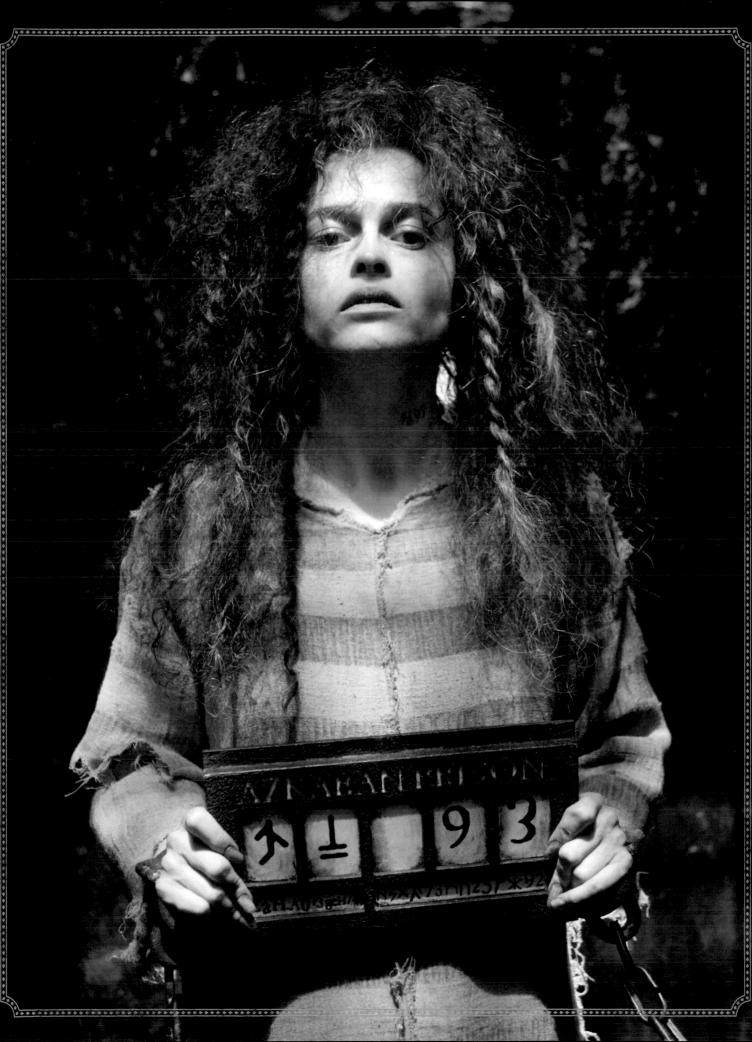

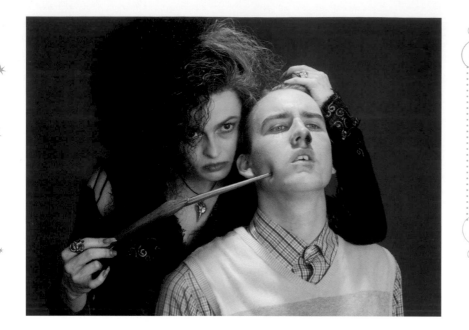

FIRST APPEARANCE:
Harry Potter and the Order of the Phoenix

ADDITIONAL APPEARANCES:
Harry Potter and the Half-Blood Prince
Harry Potter and the Deathly Hallows – Part 1
Harry Potter and the Deathly Hallows – Part 2

HOUSE:
Slytherin

MEMBER OF:
Death Eaters

Each sister wears a hooded coat, in their own inimitable way. "Narcissa has much more class," says Jany Temime, "and wears everything better. But for this, I wanted them both to look like little mice drowning in the rain." Beneath her long leather coat, Bellatrix wears a dress made of a rich velvety velour that is in much better condition than her previous attire. Her face is less sunken, and more appropriately madeup. "My teeth are much cleaner," says Bonham Carter, "although I really liked the awful version." Her lips and nails are painted red. "After that," says Temime, "Bellatrix goes to war. For this she wears a fuller corset, which to me was like armor." The corset is held together by toggles that, once again, resemble a bird skull. Bellatrix wears long protective sleeves that are laced to the shoulders of her full-torso corset, and her hair is piled atop her head. "She clearly has a personality disorder," laughs Bonham Carter, "because she always thinks she looks gorgeous."

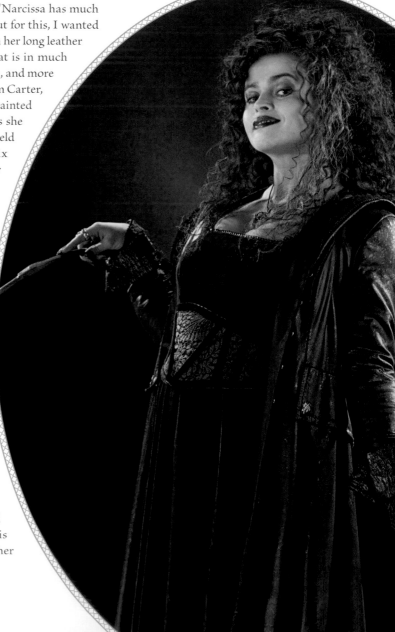

BELLATRIX'S WAND

The handle of Bellatrix Lestrange's wand has a gentle curve, roughly inscribed with runic symbols. But then it quickly plummets into a shape that resembles the talon of a bird of prey. "I have the best wand," states Helena Bonham Carter. "It gives me a long arm and it's good for doing your hair." Bonham Carter had a slight mishap during the filming of the Ministry battle in *Harry Potter and the Order of the Phoenix* with Matthew Lewis (Neville Longbottom). "I thought I could brandish the wand sort of like a Q-tip and clean out his ear. Sort of torture it. But unfortunately he moved toward the wand and it actually perforated his eardrum." Fortunately, Lewis healed within a few days, affirming that, "Helena plays her character really well."

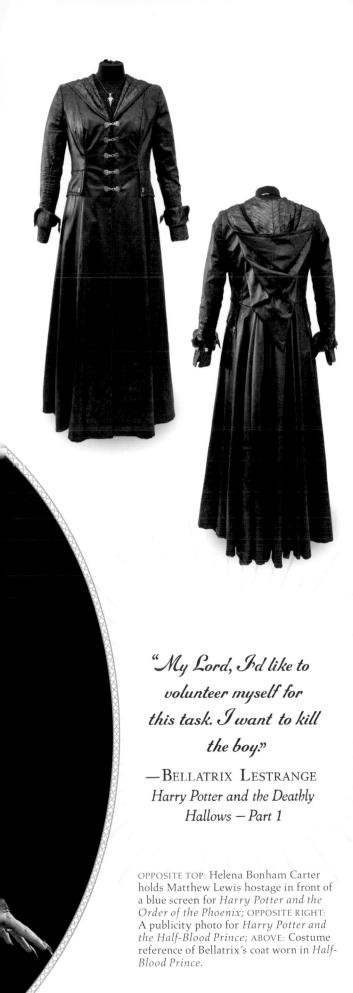

Hermione as Bellatrix

For Harry Potter and the Deathly Hallows – Part 2, Jany Temime undertook creating an outfit that would be worn by both Helena Bonham Carter and Emma Watson, when Hermione takes Polyjuice Potion in order to access the Lestrange's vault in Gringotts bank. Temime decided that the best approach was to fashion a coat with a short cape that would essentially hide the differences between the younger and older woman's silhouettes. Bonham Carter studied Watson's physical mannerisms as Hermione and was provided notes from the actress on how to play the part. The research was obviously effective—Jany Temime admits to being fooled when she saw Bonham Carter as "Hermione as Bellatrix" walking around the studio and thought it was Watson.

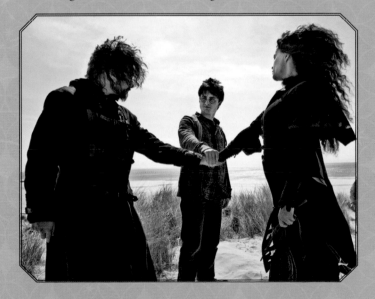

TOP: Emma Watson is doused with water for a scene shot on a green-screen set after her character emerges from a lake; ABOVE: Ron, Harry, and the Polyjuice-Potioned Hermione prepare to Apparate to Gringotts Bank, both in *Harry Potter and the Deathly Hallows – Part 2*.

> "My Lord, I'd like to volunteer myself for this task. I want to kill the boy."
>
> —Bellatrix Lestrange
> *Harry Potter and the Deathly Hallows — Part 1*

OPPOSITE TOP: Helena Bonham Carter holds Matthew Lewis hostage in front of a blue screen for *Harry Potter and the Order of the Phoenix*; OPPOSITE RIGHT: A publicity photo for *Harry Potter and the Half-Blood Prince*; ABOVE: Costume reference of Bellatrix's coat worn in *Half-Blood Prince*.

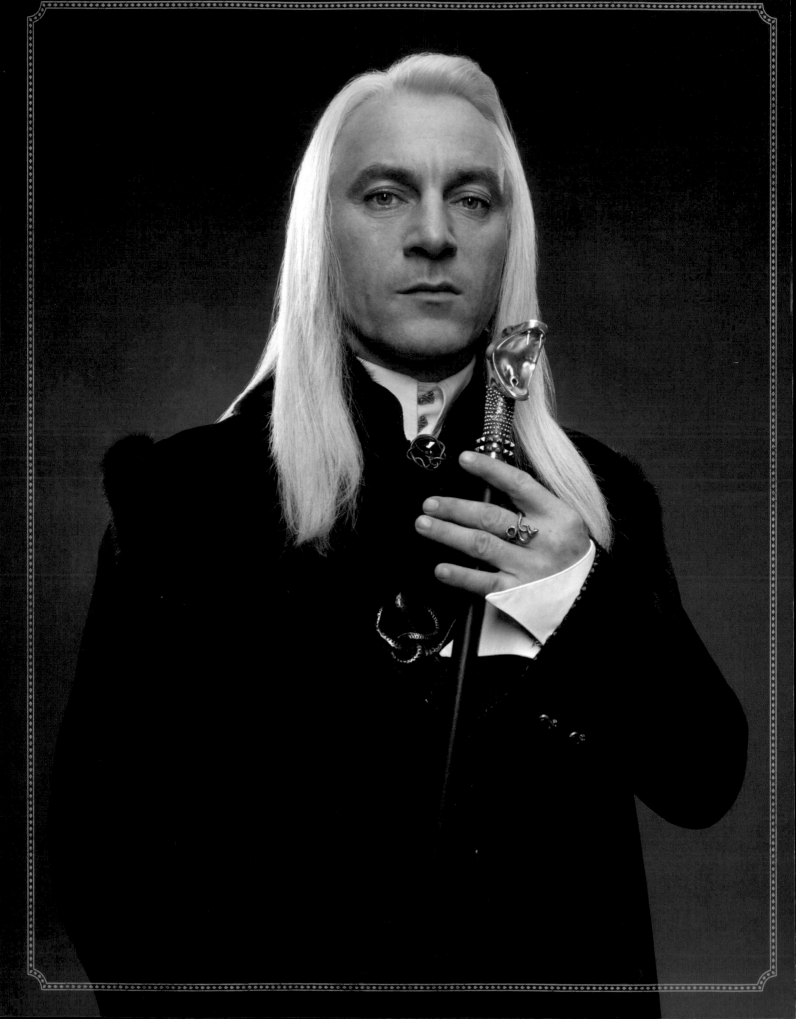

LUCIUS & NARCISSA MALFOY

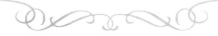

W hen Jason Isaacs arrived at Leavesden Studios for costume and makeup consultations for his part of Lucius Malfoy in *Harry Potter and the Chamber of Secrets*, he was surprised that initial sketches for the character showed a man in a pin-stripe suit with short, dark hair. "I panicked slightly," Isaacs recalls, "because it looked just like me!" Isaacs didn't see a physical connection to Tom Felton's character (Draco Malfoy) and spoke with director Chris Columbus, who had already approved the sketches. "I thought, as Lucius despises Muggles, he wouldn't want to dress like one. I thought he'd wear outfits made of velvet and fur, and ornament himself in things that had been in his family for hundreds of years." Isaacs asked the costume department to help him show Columbus his ideas, including a provisional white-blonde wig, and the director was slowly persuaded to make the change. "'Is there anything else?' he asked me, and I said yes, I wanted a walking cane. And he said, 'Why, is there something wrong with your leg?'" Isaacs explained that he thought it would be an interesting affectation, and that his wand could come out of the cane, unlike other wizard's, who kept their wands in pockets. "Fortunately, Daniel Radcliffe was there and said that sounded cool. And more fortunately, Chris Columbus is a very open-minded, collaborative sort of man and let the original concept go."

Associate costume designer Michael O'Connor agreed that Lucius should suggest an establishment-type figure, "like bankers, people with a lot of money, and people with a very, very long bloodline or pedigree. He's from the old school of wizards and doesn't like those that aren't pure-bloods. So we started with that." The elder Malfoy's tailoring is sleek and slightly Edwardian, with high-necked long frock coats under an ermine-collared cape that is held together by one of several pieces of serpentine-style silver jewelry. For *Harry Potter and the Order of the Phoenix*, Jany Temime designed a quilted leather armor that Lucius—and other Death Eaters—wear under their hooded robes; Isaacs asserts this makes him feel like "a wizard ninja." And even though he still sports the cane, Lucius was given a wand holster that incorporates snake heads in its design for battle scenes. For *Harry Potter and the Deathly Hallows – Part 1* and *Part 2*, after Lucius returns from a stint in Azkaban, his costumes are distressed and his hair is disheveled as he had been beaten down from his experience.

Isaacs says he found Lucius easy to play and gives much credit to the costume and makeup departments. "I have these long, flowing robes, but with no pockets to stick my hands into, so I can't slouch. The cane also encourages me to stand in a particular way. And in order to keep my lovely, long blonde hair straight, I have to tilt my head back. It means I'm always looking down my nose at someone." Another credit he offers is to his inspiration for the development of Lucius's voice. "It drips with entitlement and superiority, like a snotty art critic. It's unctuousness with a very pinched, strangled sound." And the inspiration? "Well, when you're in the same film as Alan Rickman, who has set the bar very high for playing 'sinister,' you have to do something extreme!"

Actress Helen McCrory concedes that her character's name gave her insight into

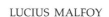

LUCIUS MALFOY

FIRST APPEARANCE:
Harry Potter and the Chamber of Secrets

ADDITIONAL APPEARANCES:
Harry Potter and the Goblet of Fire
Harry Potter and the Order of the Phoenix
Harry Potter and the Deathly Hallows – Part 1
Harry Potter and the Deathly Hallows – Part 2

HOUSE:
Slytherin

MEMBER OF:
Death Eaters

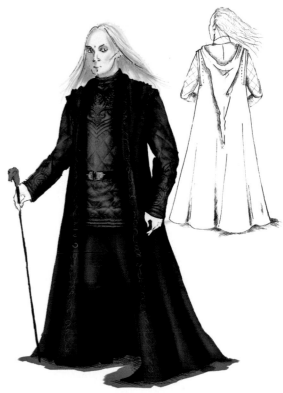

INSET: Jason Isaacs as Lucius Malfoy; OPPOSITE: Isaacs demonstrates a perfect Lucius Malfoy sneer in a publicity photo for *Harry Potter and the Order of the Phoenix*; RIGHT: Sketches for Lucius's Death Eater robes for *Harry Potter and the Deathly Hallows – Part 2,* by Mauricio Carneiro.

> *"Is he alive? Draco.*
> *Is he alive?"*
>
> —NARCISSA MALFOY
> *Harry Potter and the Deathly*
> *Hallows – Part 2*

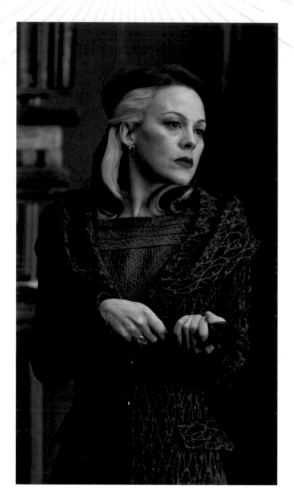

her look. "I mean, you just can't arrive looking like a mess when you're called Narcissa!" McCrory and Jany Temime looked at very European "aristocratic" cuts and lines and landed on a style that reflects the tailored couture of the 1950s. "Even though she's in a low period of her life," explains Temime, "she is still extremely elegant and chic." Narcissa's clothes reflect her own pure-blood status, her Slytherin heritage, and her devotion to her family. "The outfits are very tailored," says McCrory, "and have a lot of detail so that you feel these are clothes that her family has had for a while." The hooded and flared coat she wears at the beginning of *Harry Potter and the Half-Blood Prince* is an olive green, shot through with undulating silver lines almost scale-like in design. Temime wanted the clothes to have a very structured look, with "built-up shapes," and even inserted a wood frame into the shoulders of the coat. Later, on a visit with Draco to Borgin and Burkes, Narcissa wears a gray suit with an A-line skirt and a peplum-waisted short coat that sports cape-like sleeves and back. "Her clothes should have some mystery, and some strangeness," she says, "but are based in reality. At least, her reality."

For *Harry Potter and the Deathly Hallows – Part 1* and *Part 2*, Narcissa is hosting Voldemort and his followers in her house. "She is very much the lady of the manor," says Temime. For "receiving," as Temime calls it, she fabricated a black velour robe with a beige sheath dress underneath it. The robe has cuffs, pockets, and its front is embellished with iridescent beads set in a winding, sinewy design. During the daytime meetings of the Death Eaters, Narcissa wears another short suit with a paneled front and cinched waist in a decidedly scaly fabric. Her long black robe is cloned for outdoor use in a thicker fabric with mink around its neck, silver bindings, and leather enhancements that, as always, curl around her cuffs and neckline.

Narcissa's hair is what Helen McCrory describes as "quite otherly. Helena [Bonham Carter] had filmed Bellatrix with dark hair, and they *are* sisters, so . . ." McCrory is a natural brunette, but the idea was suggested by hair designer Lisa Tomblin that as Narcissa had been with the Malfoys for so long, her hair would reflect both wizarding families. "We tried different types of blonde hair, and different configurations, and finally, we came up with this," Tomblin says, referring to Narcissa's mashup of blonde and brunette tresses. But McCrory feels that the hairstyle is a match to Narcissa's elegant style, and would be "recognizably chic in this world of witches and wizards."

NARCISSA MALFOY

FIRST APPEARANCE:
Harry Potter and the Half-Blood Prince

ADDITIONAL APPEARANCES:
Harry Potter and the Deathly Hallows – Part 1
Harry Potter and the Deathly Hallows – Part 2

HOUSE:
Slytherin

OCCUPATION:
Mother

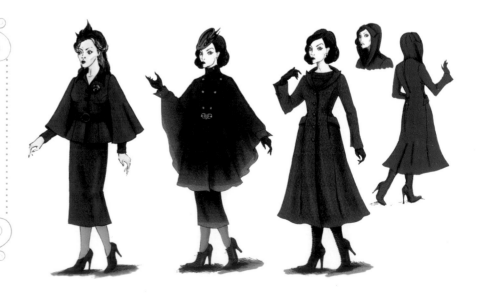

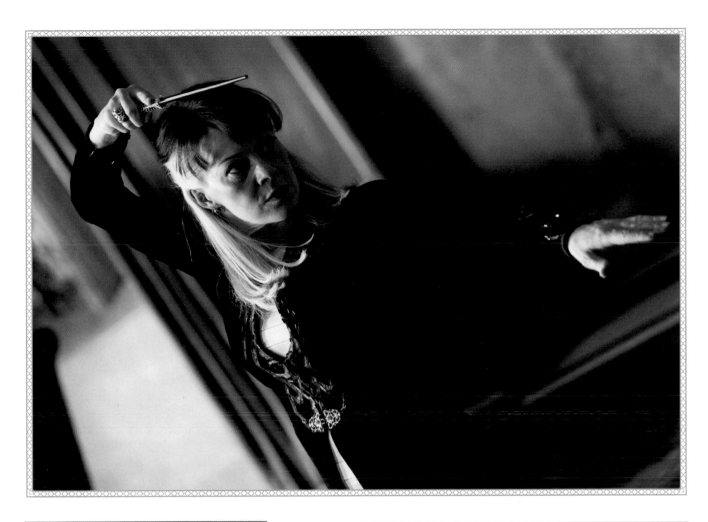

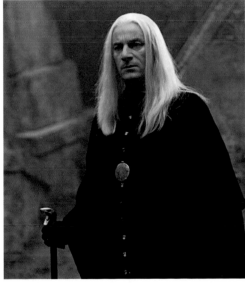

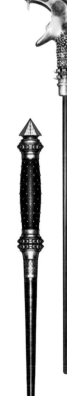

OPPOSITE LEFT: Narcissa Malfoy (Helen McCrory) in her "wood-framed" coat for *Harry Potter and the Half-Blood Prince*; OPPOSITE RIGHT: Costume illustrations for Narcissa's wardrobe, drawn by Mauricio Carneiro; TOP: Narcissa draws her wand; ABOVE: Lucius Malfoy and his snake-tipped cane, in *Harry Potter and the Goblet of Fire*; RIGHT: Concept art of Narcissa's and Lucius's wands by Adam Brockbank.

LUCIUS'S & NARCISSA'S WANDS

Lucius Malfoy's wand proudly proclaims his Slytherin roots, with its sleek black shaft topped by an open-mouthed silver snake's head with inset emerald eyes, which he encases in a walking stick. The snake head has replaceable teeth, as these would often break off when Isaacs used the cane too boisterously. For *Order of the Phoenix*, actor Jason Isaacs used a "public-school fencing style," he says. "I think watching the contrast of this formal style with Sirius Black's Azkaban-informed style is one of the enjoyable aspects of our wand battle. Not experts dueling with each other, but old adversaries."

Narcissa Malfoy's wand echoes the design of her husband's. "I tried to do a feminine version of Lucius's wand," says designer Adam Brockbank, "and then embedded silver studs into the black wood of her wand." Prop modeler Pierre Bohanna feels that the wands effectively represented their wizards. "It's all presentation with the Malfoys, I think. It's all to do with how you look rather than what the purpose is." Both Narcissa and Lucius use different, simple wands in *Deathly Hallows – Part 2*, as Lucius's wand is taken by Voldemort, and Narcissa gives her wand to her son, Draco.

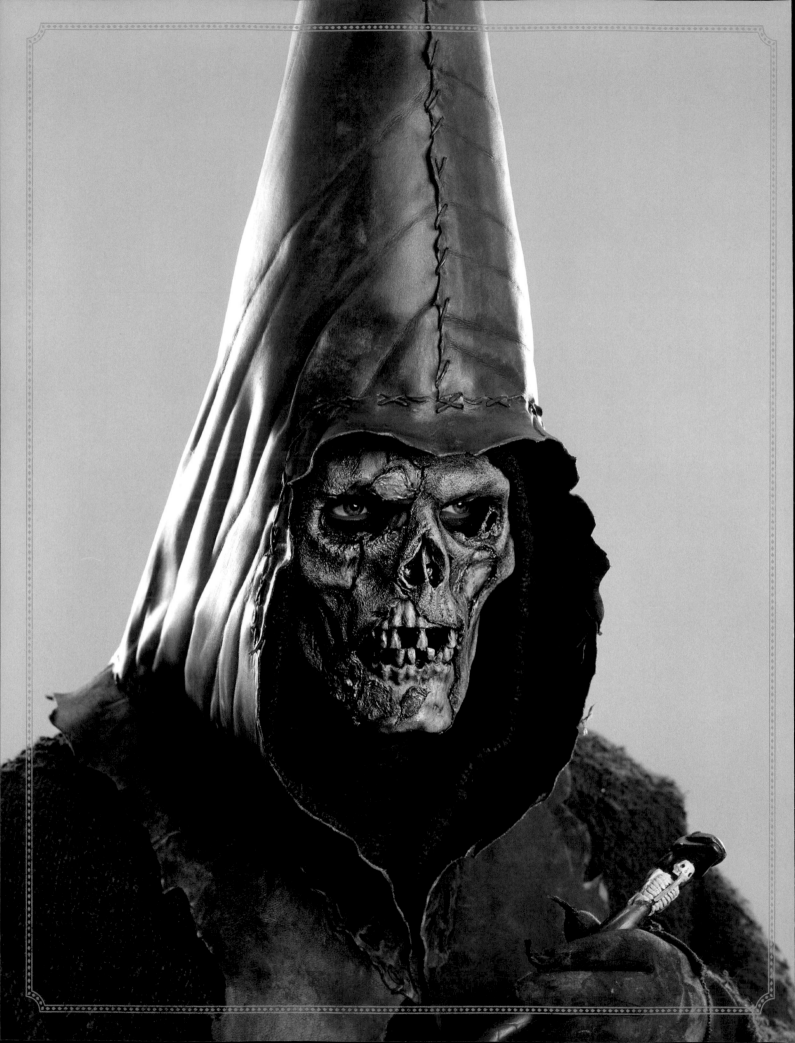

DEATH EATERS

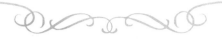

FIRST APPEARANCE:
Harry Potter and the Goblet of Fire

ADDITIONAL APPEARANCES:
Harry Potter and the Order of the Phoenix
Harry Potter and the Half-Blood Prince
Harry Potter and the Deathly Hallows – Part 1
Harry Potter and the Deathly Hallows – Part 2

Death Eaters storm the grounds around the Quidditch World Cup in *Harry Potter and the Goblet of Fire*, signaling the return of Voldemort's Dark forces. "They were only seen in silhouette," says Jany Temime, "during the attack at the World Cup or in the fog at the graveyard, so I wanted a strong recognizable profile." Simple robes and pointed leather hoods created the shape, and plain skull masks covered their faces. When Voldemort's supporters, including Lucius Malfoy, appear in the Riddle family graveyard upon being summoned, these Death Eaters wear half masks that are digitally removed.

Temime initially envisioned the Death Eaters as "a secret society in evolution. And then, because the group becomes more and more official, they get almost a uniform for battle. You can imagine people meeting in secret and then changing their costume into something battle ready. The first time we see them, they are frightening. Then they become aggressive." Beginning in *Harry Potter and the Order of the Phoenix*, with forty Death Eaters, the capes were made from a much thicker material. Underneath, embroidered leather doublets were outfitted with a wand scabbard and protective arm cuffs and leg guards. For the battle waged in *Harry Potter and the Deathly Hallows – Part 2*, leather neck collars were added. The top of the hoods now draped over full-face masks, and fell into a serpentine trail down their backs. Costume fabricator Steve Kill was tasked with creating more than six hundred Death Eater outfits for *Harry Potter and the Deathly Hallows – Part 2*—two hundred for actors, and another four hundred for their doubles and stunt doubles. "We were given instructions by Jany

INSET: Digital artwork portrays the special effects surrounding a Death Eater in *Harry Potter and the Goblet of Fire*; OPPOSITE: Costume reference of a Death Eater seen in *Goblet of Fire*; TOP: Death Eaters at the Quidditch World Cup; RIGHT: Death Eater costume design by Jany Temime for *Harry Potter and the Order of the Phoenix*, drawn by Mauricio Carneiro.

ABOVE: Director Mike Newell goes over the scene in Little Hangleton graveyard where the Death Eaters have assembled in *Harry Potter and the Goblet of Fire*; BELOW AND OPPOSITE TOP RIGHT: Jany Temime's simple silhouette for the Death Eaters in costume illustrations, drawn by Mauricio Carneiro; OPPOSITE LEFT: Visual development artwork of Death Eater wands by Ben Dennett; OPPOSITE RIGHT: An elaborate Death Eater costume drawn by Paul Catling.

Temime," says Kill, "that for the majority of the Death Eaters she wanted something simple, because they were of a low grade. Then there are the aristocratic ones that surround Voldemort, so more ornate patterns were required." The most elaborate work went on the ten closest "lieutenants" of the Dark Lord, who each wore a unique design that indicated more their wealth than their rank. Female Death Eaters not only required smaller versions of the costumes, but the tracery and designs were less sophisticated as it was felt that anything more complicated would be overwhelming. Real leather was used, not only because it was actually less expensive than using a PVC-based material, but because "being the real thing, it looked like the real thing," says Kill. Metal workers added decorations and fastenings, and then hammered, sanded, and tarnished them to look battle worn.

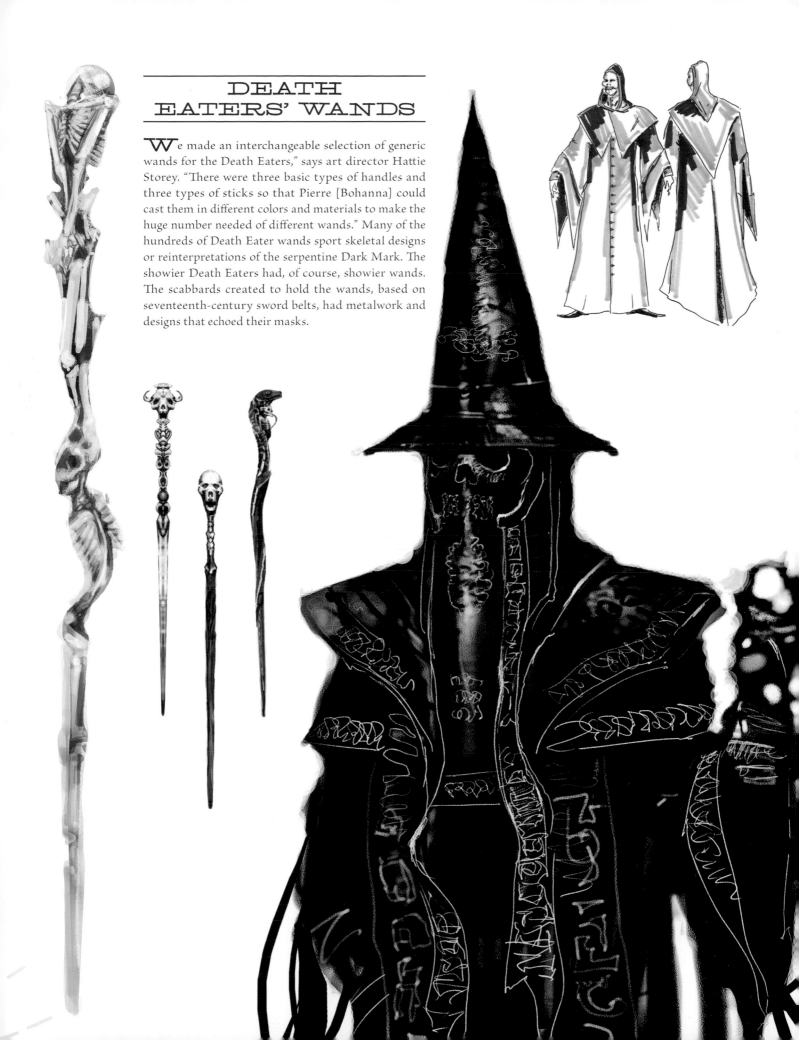

DEATH EATERS' WANDS

"We made an interchangeable selection of generic wands for the Death Eaters," says art director Hattie Storey. "There were three basic types of handles and three types of sticks so that Pierre [Bohanna] could cast them in different colors and materials to make the huge number needed of different wands." Many of the hundreds of Death Eater wands sport skeletal designs or reinterpretations of the serpentine Dark Mark. The showier Death Eaters had, of course, showier wands. The scabbards created to hold the wands, based on seventeenth-century sword belts, had metalwork and designs that echoed their masks.

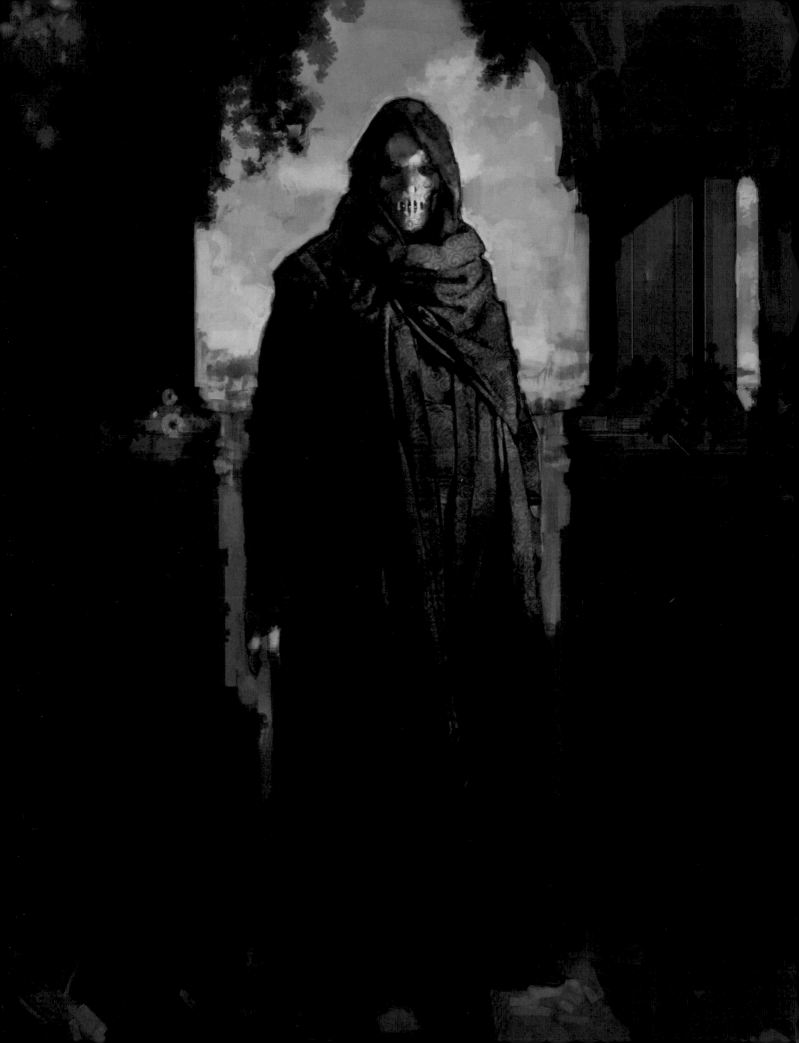

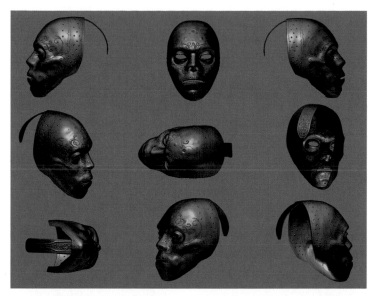

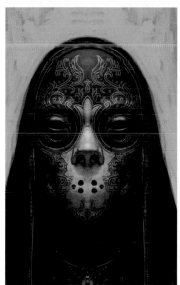
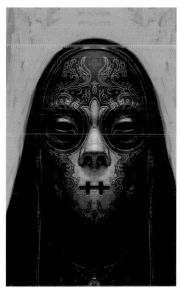

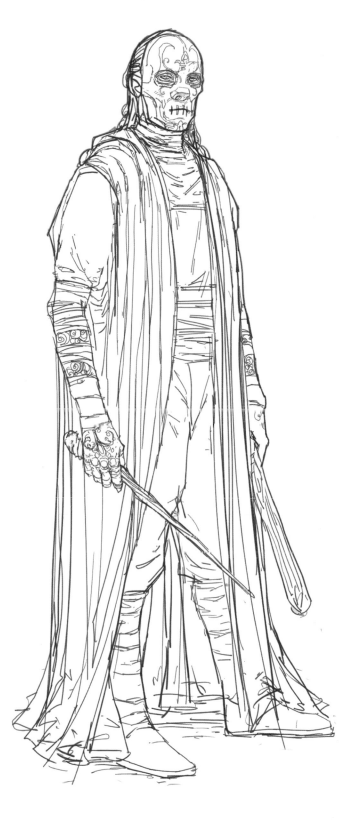

Although the Death Eaters' faces were initially covered by half masks, concept artist Rob Bliss had always envisioned the masks to be full face. "The first time we see the Death Eaters, in *Goblet of Fire*, the masks are only partially on their faces," explains Bliss. "But in *Order of the Phoenix*, I thought it would be creepy to cover the whole face." Bliss felt that though there should be uniformity in the general silhouette, individuality could be expressed in the design of the masks, for personal identification and for prestige. "I think the Death Eaters have got quite showy aesthetics," says prop modeler Pierre Bohanna. "Their clothing is intricate, and so the idea of their masks being used to show-off isn't surprising." The masks almost evoke the torture devices of medieval times, and are decorated in early Celtic and runic symbols, and filigree similar to Mogul arabesque patterns of sixteenth- and seventeenth-century Islamic India. The masks are not painted but electroplated with silver. "This works on film so well," explains Bohanna. "It reacts well to light and it's got a quality that you just can't replicate with paint."

OPPOSITE AND ABOVE: Concept art of masked, fully robed Death Eaters by Rob Bliss for *Harry Potter and the Order of the Phoenix*; TOP LEFT: Digital views of a Death Eater mask with tracery impressions; CENTER LEFT: Two concepts for masks by Rob Bliss.

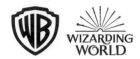

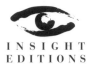

INSIGHT EDITIONS

PO Box 3088
San Rafael, CA 94912
www.insighteditions.com

❖ Find us on Facebook: www.facebook.com/InsightEditions
❖ Follow us on Twitter: @insighteditions

Library of Congress Cataloging-in-Publication Data available.

ISBN: 978-1-68383-832-6

Publisher: Raoul Goff
President: Kate Jerome
Associate Publisher: Vanessa Lopez
Creative Director: Chrissy Kwasnik
Designer: Megan Sinead Harris
Editor: Greg Solano
Managing Editor: Lauren LePera
Senior Production Editor: Rachel Anderson
Production Director/Subsidiary Rights: Lina s Palma
Senior Production Manager: Greg Steffen

Text by Jody Revenson

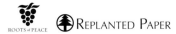

ROOTS of PEACE · REPLANTED PAPER

Insight Editions, in association with Roots of Peace, will plant two trees for each tree used in the manufacturing of this book. Roots of Peace is an internationally renowned humanitarian organization dedicated to eradicating land mines worldwide and converting war-torn lands into productive farms and wildlife habitats. Roots of Peace will plant two million fruit and nut trees in Afghanistan and provide farmers there with the skills and support necessary for sustainable land use.

Manufactured in China by Insight Editions

10 9 8 7 6 5 4 3 2 1

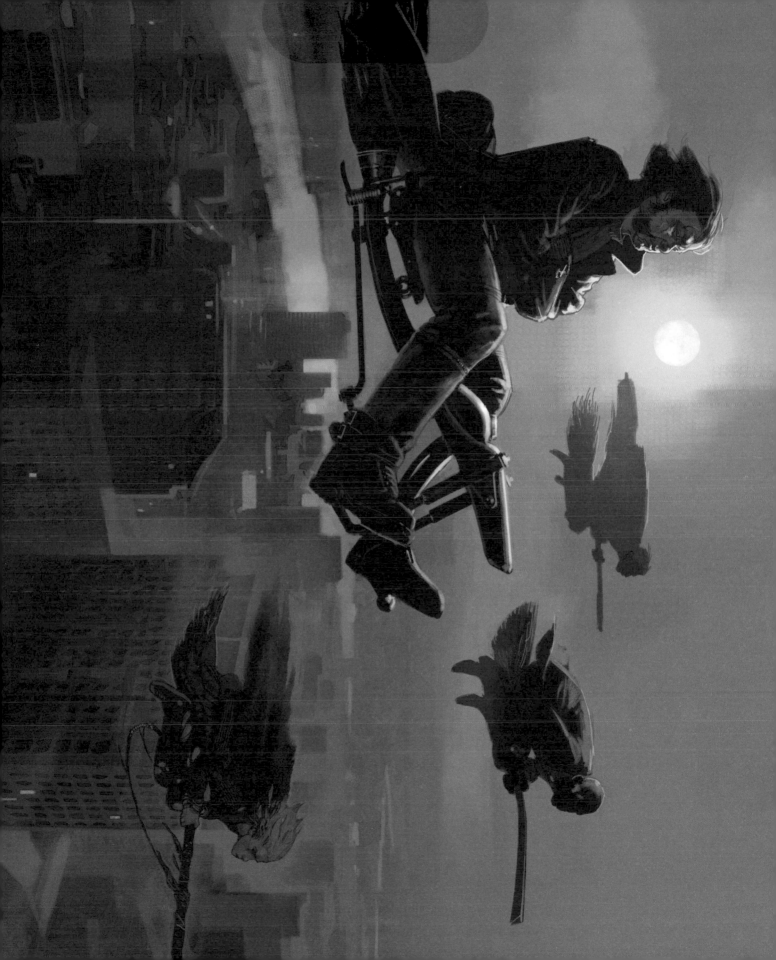